Trace & Paint
Watercolour

SEARCH PRESS

First published in Great Britain 2010

Search Press Limited
Wellwood, North Farm Road,
Tunbridge Wells, Kent TN2 3DR

Based on the following books published by Search Press:

Ready to Paint: Watercolour Landscapes
by Terry Harrison, 2007
Ready to Paint: Watercolour Trees & Woodlands
by Geoff Kersey, 2008
Ready to Paint: Watercolour Hills & Mountains
by Arnold Lowrey, 2009

ISBN: 978-1-84448-552-9

The Publishers and authors can accept no responsibility for any
consequences arising from the information, advice or instructions given
in this publication.

Suppliers
If you have any difficulty obtaining any of the materials and equipment
mentioned in this book, please go to the Search Press website:

www.searchpress.com

You are invited to visit the authors' websites:

www.lowreyart.co.uk
www.terryharrison.com
www.geoffkersey.co.uk

Publisher's note
All the step-by-step painting photographs in this book feature
the authors, Terry Harrison, Geoff Kersey and Arnold Lowrey
demonstrating watercolour painting techniques. No models have been
used apart from on page 9.

Please note that when removing the perforated outline sheets from
the book, score them first, then carefully pull out each sheet.

Printed in China

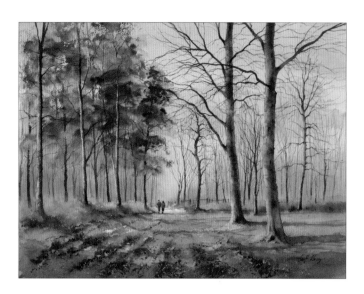

Page 1
Summer Village *by Terry Harrison*
42 x 29.5cm (16½ x 11⁵/₈in)

*This bright, sunlit scene uses the same outline as the Village in the
Snow project which begins on page 42. Poppies and other splashes
of red have been added as a complementary balance to the mainly
green colour scheme of the summer scene.*

Above
Winter Morning, Manners Woods *by Geoff Kersey*
54.5 x 43cm (21½ x 17in)

*This is a delightful wooded area high above Chatsworth Park in
Derbyshire. I tried to infuse the scene with warm colour and bright
light. Note that even the muddy foreground is full of warm reds and
purples, with a few indications of scattered fallen leaves in yellows
and oranges. Note how a feeling of distance is created by the more
distant trees being rendered in cooler, paler colours.*

Opposite
A Green Hill Far Away *by Arnold Lowrey*
76 x 56cm (30 x 22in)

*Although the farm buildings are fairly prominent, the hill is the
dominant focal point in this painting. I have used complementary
colours (reds) to the greens to make it come alive.*

Pages 4–5
Bluebell Wood *by Geoff Kersey*
56 x 38cm (22 x 15in)

*I love walking through a bluebell wood on a spring morning, with
that contrast of rich blue/violet and the fresh spring greens. This
scene is infused with bright light and vibrant colour.*

Trace & Paint
Watercolour

Terry Harrison, Geoff Kersey and Arnold Lowrey

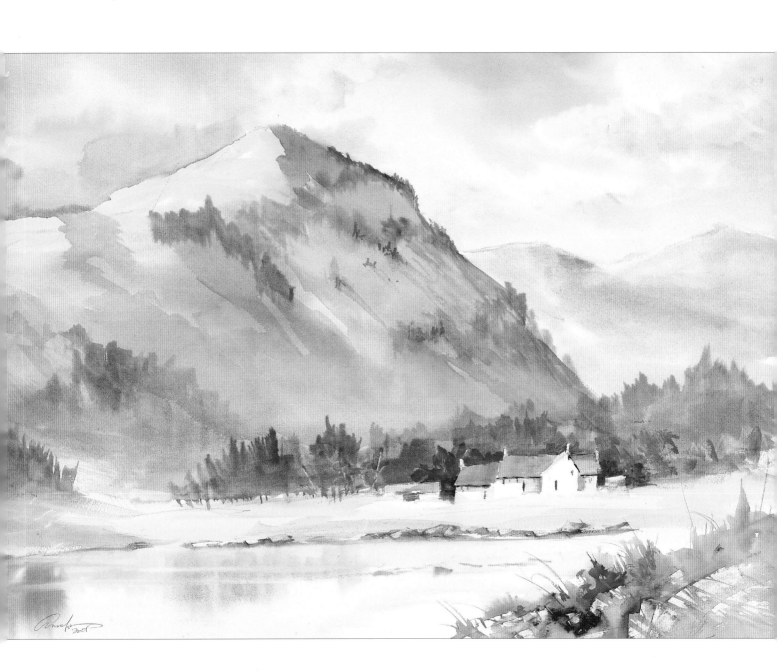

Contents

TRACING

1

Materials

Paints

Watercolour paints are available in artist and student qualities. Student quality paints cost less because they contain cheaper alternatives to some of the more expensive pigments found in artist quality paints.

The artists featured in this book all use tubes of paint as opposed to pans. The colours, when used straight from the tube, are more intense, and it is easier and quicker to mix accurate washes on the palette. Pans, however, are better if you intend to paint outdoors as they are easier to transport.

You do not need to buy dozens of colours to start with, as there is a lot you can do using only a limited palette of the primary colours, plus a few extras.

Tube colours can be squeezed into the wells of a palette like this, ready for mixing.

Paper

There are three types of paper surface: HP (hot pressed, or smooth), Not (cold pressed, or medium) and Rough. Rough paper has a 'tooth' which allows you to achieve some dry brush effects, useful for landscapes.

Paper also comes in different weights. If you are using anything lighter than 300gsm (140lb), you might need to stretch the paper, as it will cockle when wet. Immerse it in water for a minute, lay it flat on a painting board and leave it for a few minutes. It will expand, so pull it flat and secure it with gummed tape or staples. The paper contracts as it dries and creates a flat surface.

Brushes

There is a huge range of paintbrushes available for watercolour, and artists vary widely in the choices they make. Sable brushes are the best quality but are quite expensive, whereas synthetics, though cheaper, offer less control over the amount of water they give out. A good compromise are sable-nylon mixes that perform well and are reasonably priced.

Terry Harrison has created his own range of brushes, designed to help you achieve effects with the minimum effort. Shown right from top to bottom are the ones used in the projects in the Landscapes section of this book. You can of course use brushes chosen from other ranges, as long as you look for the attributes described below.

The **half-rigger** has long hair with a very fine point. It holds quite a lot of paint and is ideal for adding very fine details wet on dry. It is good for painting grasses and flower stalks.

The **small detail brush** is good for painting fine details.

The **medium detail brush** is the workhorse of the range, the one you reach for most often. It holds quite a lot of paint but still goes to a fine point, and is good for painting any but the finest details.

The **large detail brush** holds a lot of paint, so is ideal for washes, yet it goes to quite a fine point, making it very versatile.

The **fan stippler** is good for painting trees with a stippling technique. The blend of hair and bristle creates a range of textural effects that can be used to mimic elements of nature such as leaves.

The **foliage brush** is excellent for producing leafy effects and it can also be used for texture on buildings, footpaths and walls.

The 19mm (¾in) **flat brush** is useful for washes and for painting water. It can be used with a side-to-side motion to create horizontal lines such as ripples on water.

The **wizard** is made from a blend of natural hair, twenty per cent of which is slightly longer than the rest and forms small points. it is good for grasses and reflections.

The **golden leaf brush** holds lots of paint, so is ideal for sky washes or for water. It is good for stippling trees and foliage and for painting texture.

The **fan gogh** is thicker than most fan brushes and holds plenty of paint. It is good for trees, grasses and reflections in water.

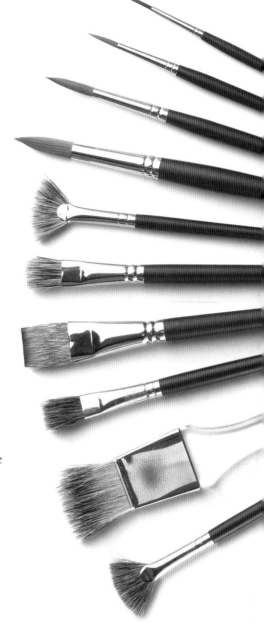

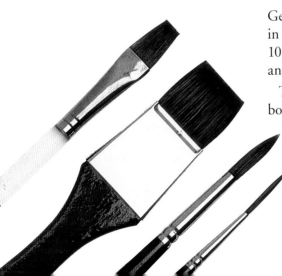

Geoff Kersey paints almost exclusively with synthetic brushes. For the projects in the Trees & Woodlands section of this book he used no. 1, no. 4, no. 8, no. 10 and no. 16 round brushes; a 13mm (½in) flat brush; a large wash brush and a no. 2 rigger.

The picture on the left shows the brushes Arnold Lowrey uses. From bottom to top they are: a no. 3 sable-nylon rigger; a no. 8 sable round brush; a 25mm (1in) sable-nylon flat brush (also known as a one-stroke brush); and a 13mm (½in) nylon flat brush with a scraper end. For the projects in the Hills & Mountains section of this book you will need only the two flat brushes and the no. 3 rigger.

Other materials

A **hairdryer** is used to speed up the drying process. Some artists prefer to allow washes to dry naturally, as the colours continue to flow into one another on the paper as they dry.

A **palette** is used for laying out and mixing your colours.

An **eraser** is used to remove masking fluid as well as to correct mistakes. Some artists prefer a hard eraser, but others like to work with a soft, kneadable **putty eraser**.

Masking fluid is used to preserve the white of the paper in areas that you do not want to be filled in with colour.

Soap is used to protect your **masking fluid brush**. Wet the brush and then coat it in soap before dipping it in masking fluid. After use, wash out the brush and the masking fluid is easily removed.

A **ruling pen** is used to apply masking fluid when you need to paint fine strokes, for instance when masking out grasses or flower stalks.

Low-tack **masking tape** is used to tape watercolour paper to your drawing board.

A 4B or 2B **pencil** is used to scribble over the back of the pull-out outline. A **burnisher** or an HB pencil can be used to go over the lines again on the front of the outline to transfer the pencil lines to the watercolour paper.

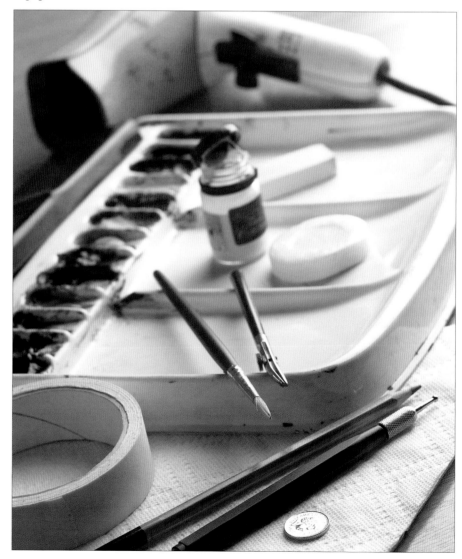

Kitchen paper is ideal for lifting out colour, drying brushes and mopping up spills. Small pieces of **sponge** are also useful for lifting out colour.

A **coin** is used wrapped in **kitchen paper** to lift out a sun shape from a wet sky wash.

The **easel** shown at top right is a box easel at which you stand to paint. You can also fold the legs away and use it on a table top. There is a slide-out shelf for your palette.

Stretch your watercolour paper on a **painting board**. These can be made from 13mm (½in) plywood, or from MDF.

Some artists use a collapsible **water pot** as these take up less space when you are carrying them around. Some like a pot with a ridged base, which is useful for cleaning brushes between washes.

A **safety razor blade** is extremely useful – use the flat edge of the blade to scrape shapes out of wet paint and the tip for scratching bright highlights out of dry paint.

Transferring the image

Pull out the outline you want to use from the middle of the book, and transferring the image to your watercolour paper could not be easier if you follow the steps shown below. You will also be able to reuse the image several times, even without going over the pencil lines again.

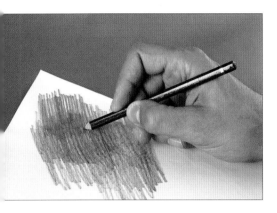

1 Place your outline face-down. Scribble over the back of the image area using a 4B or 2B pencil. You will be able to reuse this outline several times without going over scribbled graphite again.

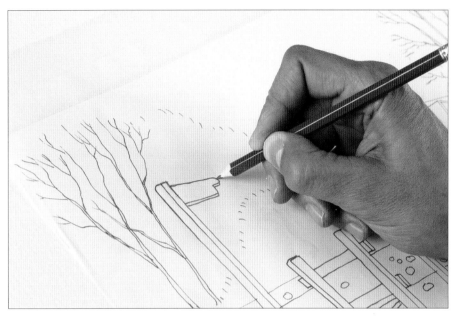

2 Tape a sheet of watercolour paper down on a board, and place the pull-out outline, face-up on top. Tape down the top of the outline only. Use a hard pencil or ballpoint pen to go over the lines. This will transfer the scribbled graphite on to the watercolour paper.

3 You can lift up the pull-out outline from the bottom as you work, to see how the transfer of the image is going.

LANDSCAPES

by Terry Harrison

You do not necessarily have to be able to draw in order to produce a watercolour painting. The idea of this book is to side-step this first hurdle.

The basic drawings for all five of the projects in this section are provided as outlines to pull out from the middle of the book. On page 9 there are simple instructions showing you how to transfer an outline on to your watercolour paper, ready to begin painting. There is also an outline of the painting that appears on this page and opposite, in case you would like to have a go at this too.

The traditional landscape is my favourite painting subject. I was inspired by artists such as Constable and Turner, and more recently by Rowland Hilder and Alwyn Crawshaw.

My aim has always been to make painting more accessible by helping to make the techniques easier. With this in mind, I have developed my own range of brushes (see page 7), used in all the demonstrations in this section. You will also find plenty of practical tips to take the mystery out of watercolour, allowing you to produce impressive results much sooner than you might expect.

Above all, remember that painting should be fun, so relax and enjoy yourself!

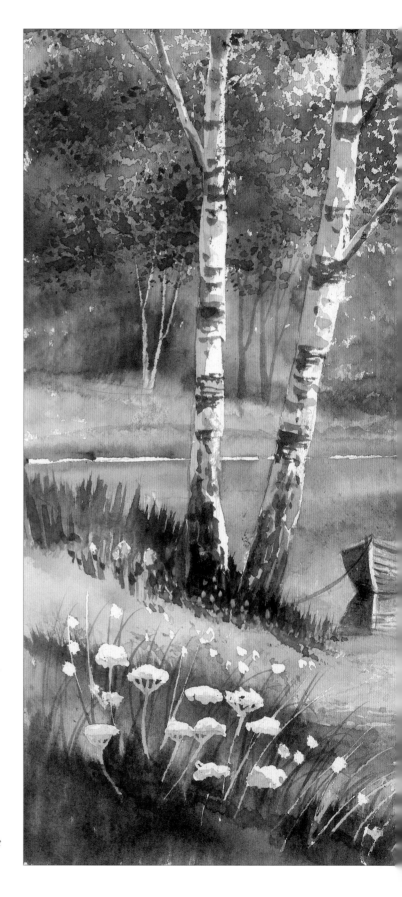

Lakeside Flowers

42 x 29.5cm (16½ x 11⁵/₈in)

The footpath in this scene leads the eye invitingly towards the lake and the boat. The flowers add a dash of colour and interest to the foreground, and tall trees with over-arching foliage frame the scene.

The outline for this painting is available to pull out from the middle of this book so that you can recreate the scene. You could experiment with different colour schemes from the one I have chosen.

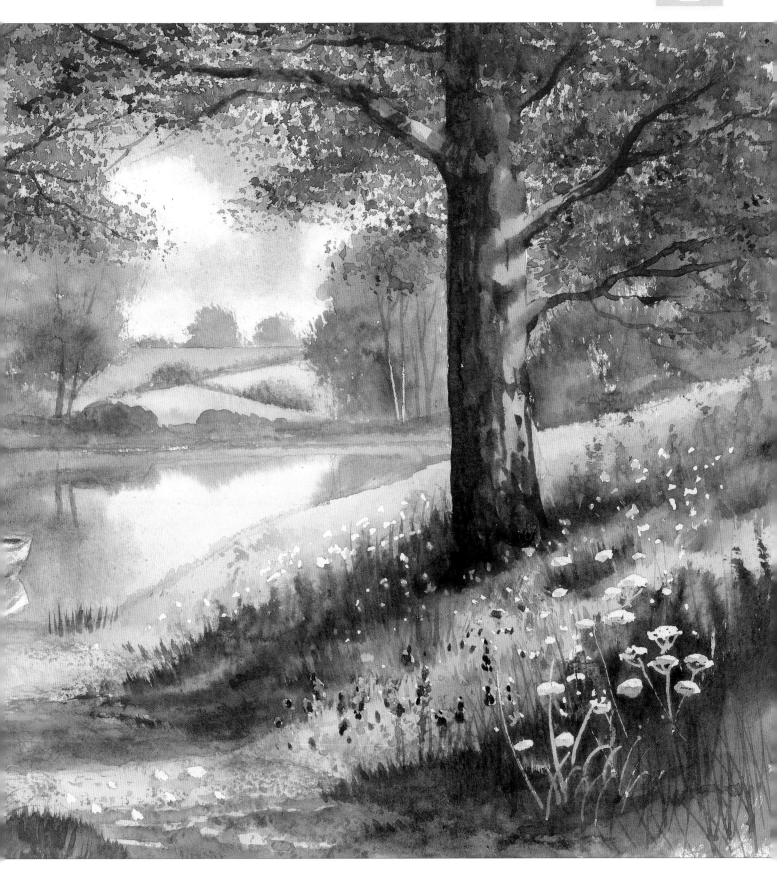

Poppy Field

This is a typical Terry Harrison scene. The subject matter is so paintable, with soft, rolling countryside, a patchwork of fields and a splash of bright colour in the foreground, framed by one of my favourite subjects, a footpath, stile and signpost.

You will need

300gsm (140lb) Rough watercolour paper

Masking tape

Masking fluid, brush and soap

Ruling pen

Colours: ultramarine, burnt umber, country olive, midnight green, sunlit green, raw sienna, burnt sienna, shadow, cadmium red

Brushes: golden leaf, foliage, medium detail, half-rigger, fan stippler, fan gogh, wizard

Kitchen paper

Magazine page

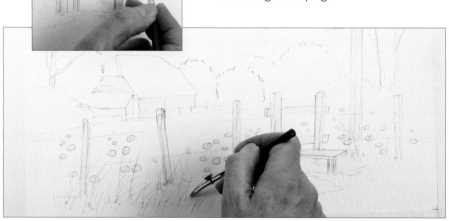

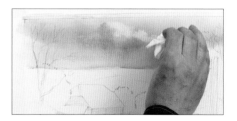

1 Transfer the image on to watercolour paper and tape the paper to your drawing board. Attach low-tack masking tape to the edges of the image. This will help to give the painting nice, clean edges.

2 Dip a small, nylon masking fluid brush in soap to coat it. This will make the masking fluid easy to remove when you have finished work. Mask all the woodwork in the painting as shown. Then mask the flowers; you can add more than are shown in the outline. Use a ruling pen dipped in masking fluid to flick up grasses. Dip the pen in about 6mm (¼in) and do not overload it or it will create blobs.

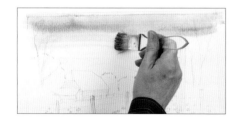

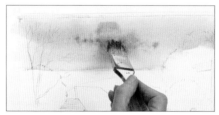

3 Wet the sky area first with clean water and apply a wash of ultramarine using the golden leaf brush.

4 Drop in clouds while the paint is still wet using the same brush and a mix of burnt umber and ultramarine. Adding wet paint to wet paint in this way is known as the wet in wet technique.

5 Use a piece of kitchen paper to lift out paint, creating highlights in the clouds.

6 Use a page from a magazine to mask off an area along the horizon. Dip the foliage brush in a fairly weak mix of country olive paint and stipple along the edge as shown. Add tree shapes.

7 Change the angle of the magazine page to paint hedgerows.

8 Still painting wet in wet, add shadows to the trees and hedgerows using midnight green. Allow the painting to dry.

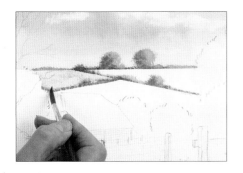

9 Use the medium detail brush and a very thin wash of midnight green to add colour to the first field.

10 Paint the second field with a thin wash of sunlit green and the third, in front, with raw sienna.

11 Still with the same brush, paint in the trees using a greeny mix of country olive and burnt umber. You can add branches if you like.

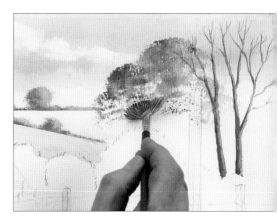

12 Use a half-rigger brush to paint the twigs.

13 Paint the trees on the right in the same way. Shade the left-hand side with a stronger mix of country olive and burnt umber.

14 Take the fan stippler brush and double-load it, picking up country olive paint on the left-hand side and sunlit green on the right. Paint the trees behind the signpost with a dabbing motion.

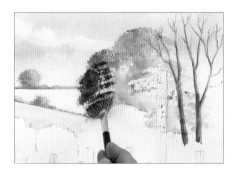

15 Add midnight green on the left-hand side of the trees behind the signpost.

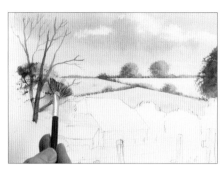

16 Still using the fan stippler, paint raw sienna on the sunlit side of the left-hand tree and midnight green on the left.

17 Mask off the field using a magazine page. Use the foliage brush to stipple pale country olive paint to create a bush in front of the left-hand tree.

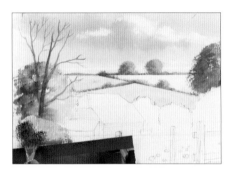

18 Use a darker mix of country olive to shade the left-hand side and underside of the bush.

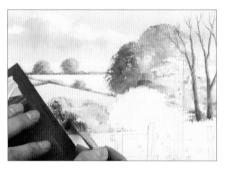

19 Mask the barn roof with the magazine page. Paint the bushes to the right in the same way as before, and darken the shaded left-hand side with midnight green.

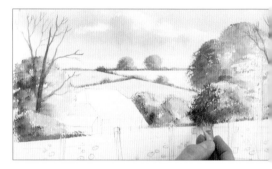

20 Continue painting bushes to the right, using sunlit green with a hint of burnt sienna on the right and midnight green to shade the left-hand side.

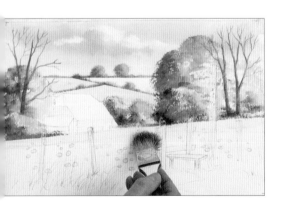

21 Use the golden leaf brush and a light wash of raw sienna to paint the back of the cornfield.

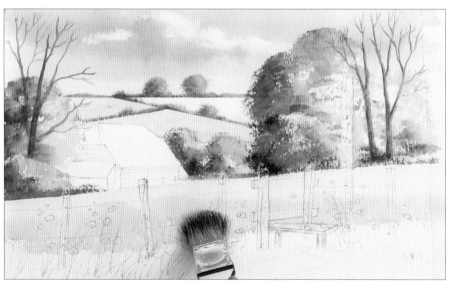

22 Paint a stronger mix of the same colour as you come towards the foreground.

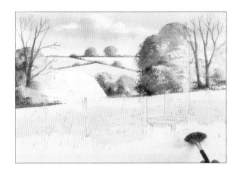

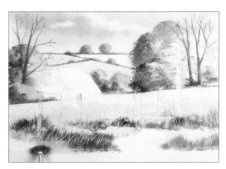

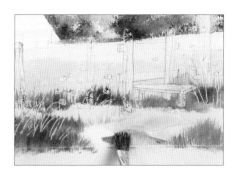

23 Paint sunlit green along the fence line and on the other side of the footpath using the fan gogh brush.

24 Flick up grasses in the foreground using the same brush and country olive. Use a lighter mix of country olive at the bottom left.

25 Use the wizard brush to paint the footpath with raw sienna further back and add burnt sienna towards the foreground.

26 Paint the barn roof with the medium detail brush and a thin wash of burnt sienna. Drop in shadow colour wet in wet to suggest roof tiles.

27 Paint a stronger mix of burnt sienna on the lean-to roof. Drop in a touch of ultramarine wet in wet. This colour causes an interesting textural effect called granulation.

28 Paint on a mix of burnt umber and country olive for the front of the barn.

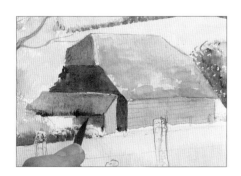

29 Paint the face of the lean-to with a stronger mix of the same colours.

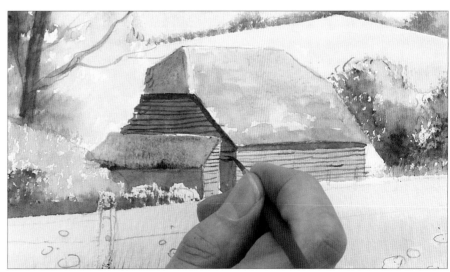

30 Use a half-rigger and the same strong mix to paint the shadow under the roof. Carefully paint broken lines for the weatherboarding. Strengthen the mix further to paint the weatherboarding on the end gable.

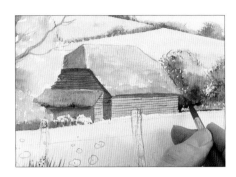

31 Use midnight green to darken the white triangle left by masking.

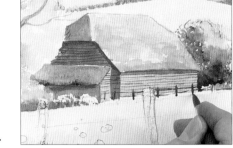

32 Paint the fence using the same colour.

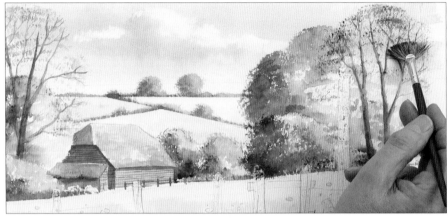

33 Double-load the fan stippler brush with sunlit green on the right and midnight green on the left and lightly stipple foliage over the larger trees, leaving some gaps.

34 Pick up a little raw sienna and burnt sienna on the fan gogh brush and flick up standing corn in the field.

35 When the paint is dry, remove the masking fluid by rubbing with clean fingers.

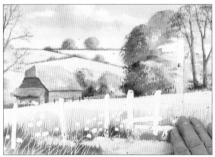

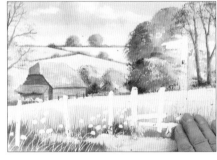

36 Paint all the woodwork with the medium detail brush and a thin wash of raw sienna and sunlit green.

37 Wash sunlit green over the grasses, avoiding the flower heads. Allow the painting to dry.

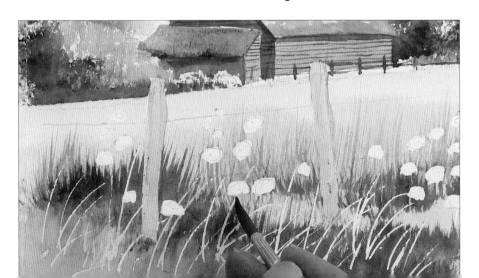

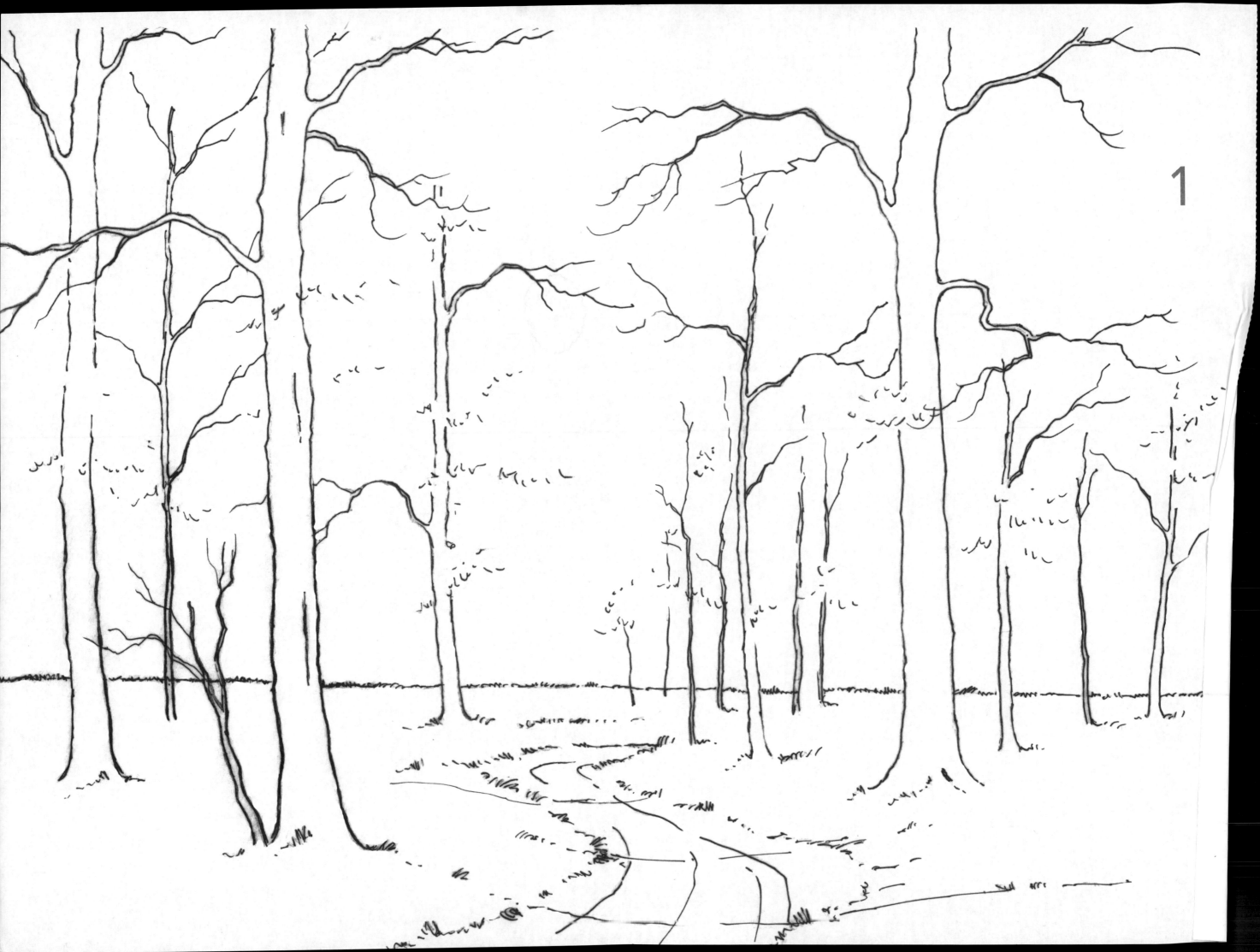

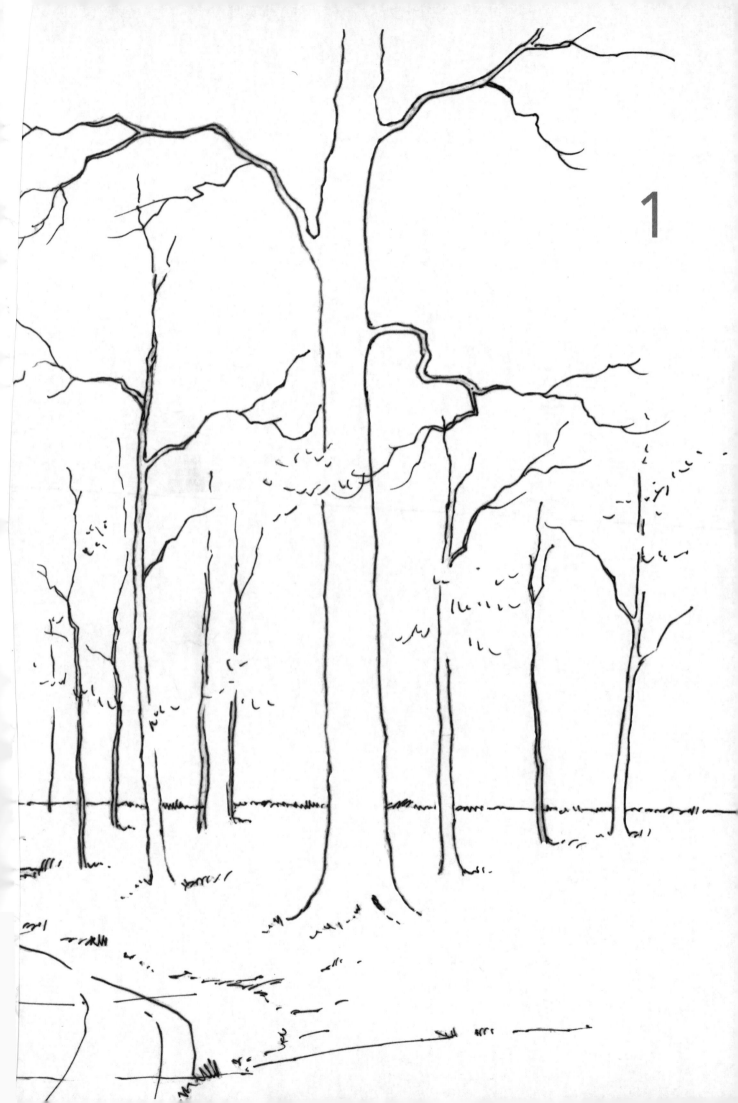

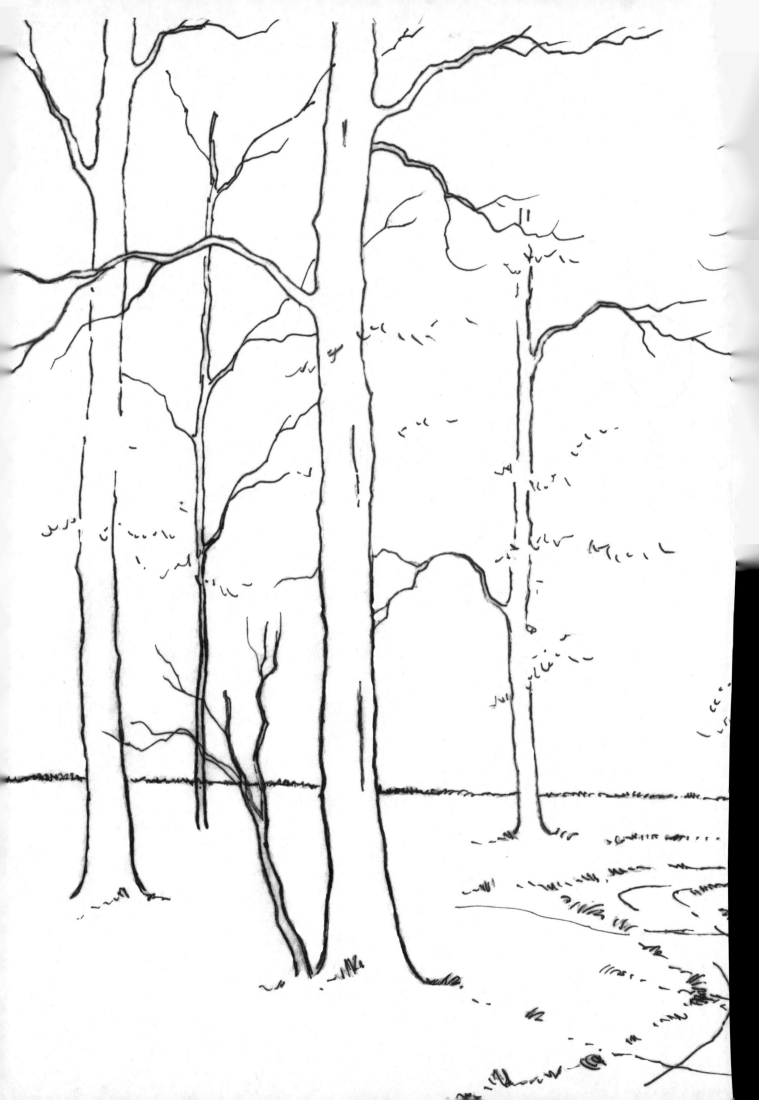

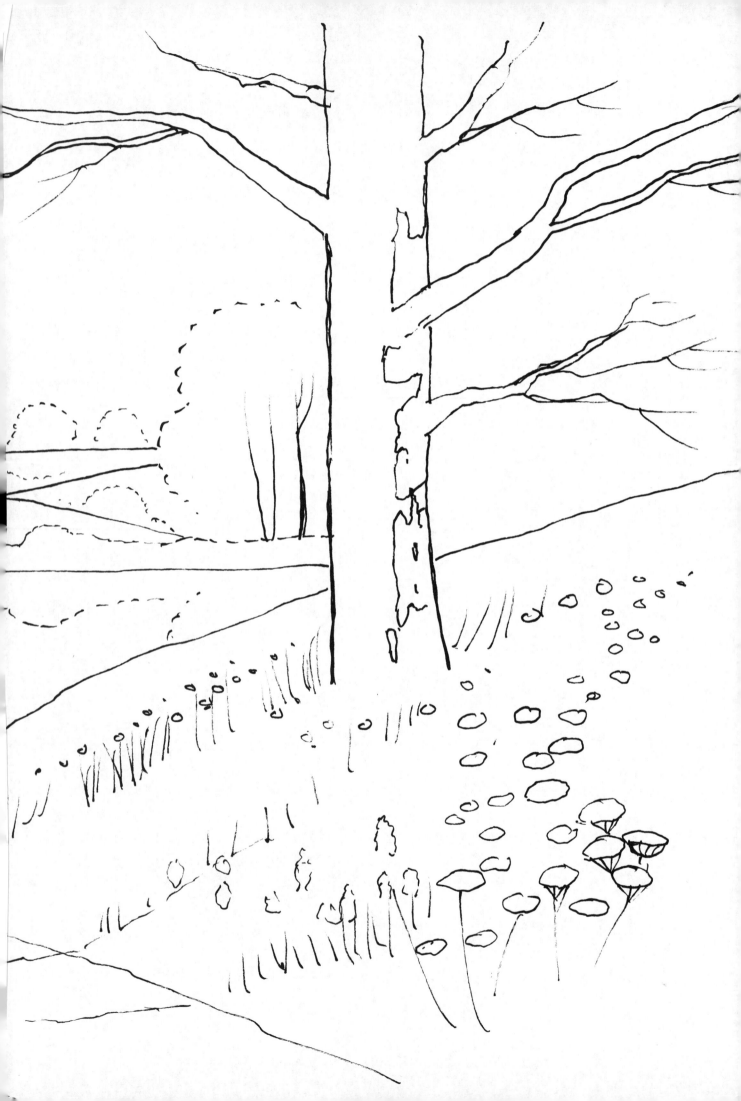

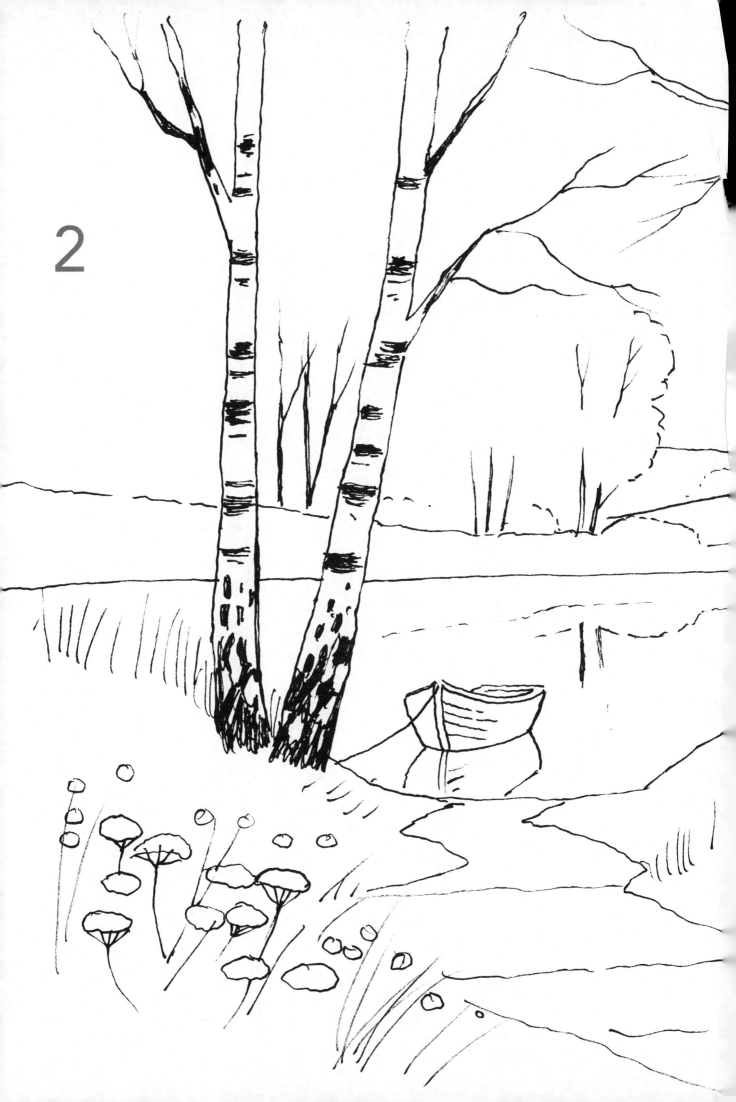

2

38 Use country olive and burnt umber to paint the shaded side of the woodwork, and the shadows cast by the posts on the horizontals of the stile.

39 Paint the poppies by applying a light wash of cadmium red, then dropping in a deeper mix of the same colour wet in wet.

40 Use midnight green and the fan gogh brush to create more texture in the grasses.

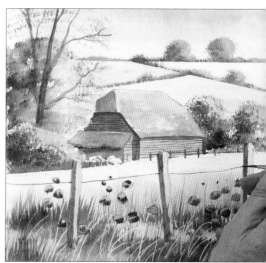

41 Change to the foliage brush and use midnight green to stipple foliage on the trees.

42 Use the half-rigger and burnt umber with a touch of country olive to paint in the fence wire.

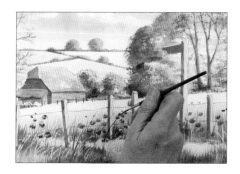

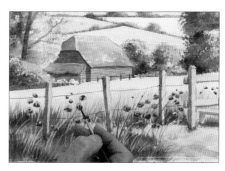

43 Still using the half-rigger, flick up tall grasses among the poppies with country olive.

44 Put in the centres of the poppies using the colour shadow and the tip of the half-rigger.

45 Remove the masking tape to reveal the edges of the painting. Pull the tape away from the painting.

Overleaf

The finished painting.

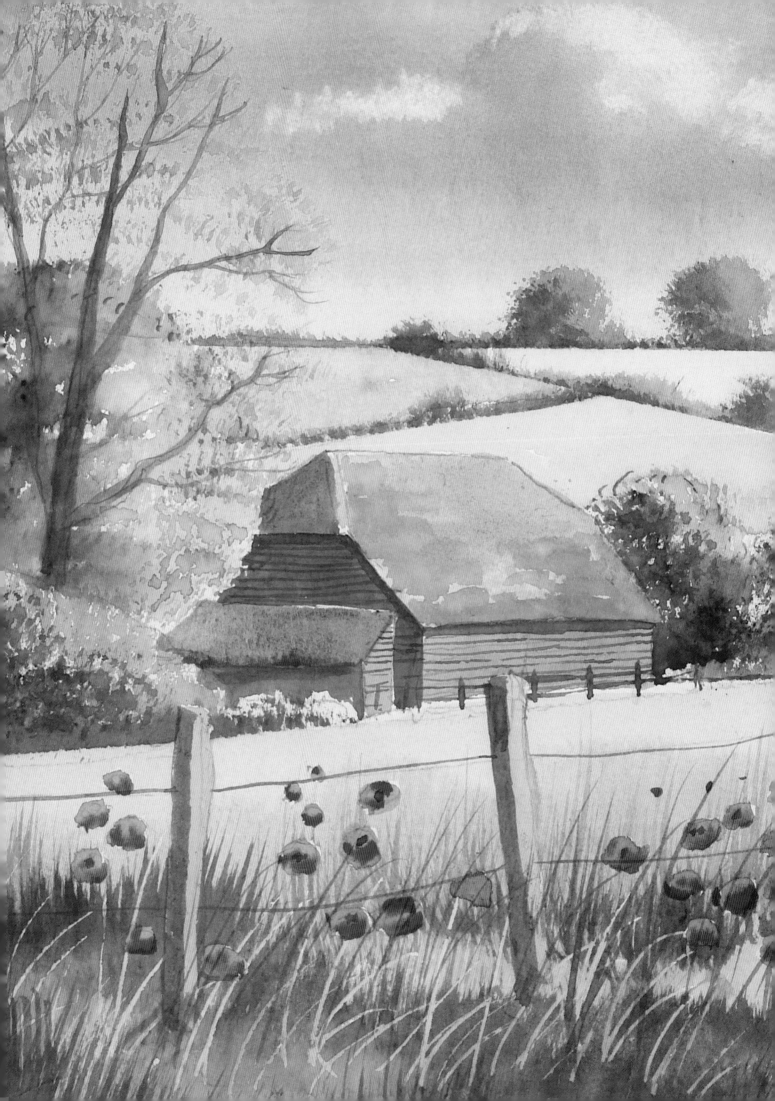

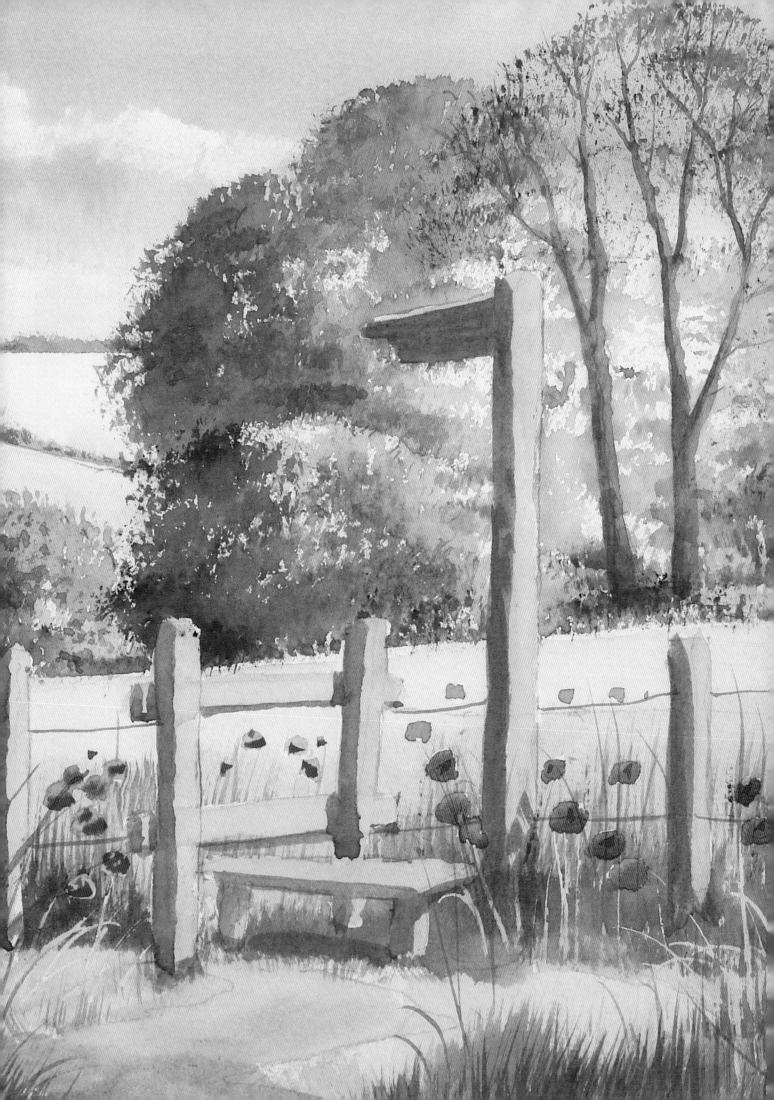

Doorway

The beauty of this subject is in the vibrant colours and warm sunlight, reminiscent of hot summer days or a favourite holiday. This is a simple scene with a strong, bright feel about it.

You will need

300gsm (140lb) Rough watercolour paper

Masking tape

Masking fluid, brush and soap

Colours: raw sienna, burnt sienna, burnt umber, shadow, sunlit green, country olive, midnight green, cobalt blue, ultramarine, permanent rose, cadmium red

Brushes: golden leaf, medium detail, large detail, foliage, half-rigger

1 Transfer the image from the outline on to watercolour paper. Apply masking tape to the edges. Mask off the flowers using masking fluid. Paint over the stonework with the golden leaf brush and a pale wash of raw sienna.

2 While the paint is still wet, dab into it with a stronger mix of raw sienna with a touch of burnt sienna, to create a mottled effect.

3 Paint the gravel with raw sienna and a touch of burnt umber.

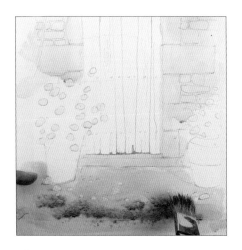

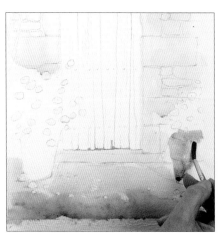

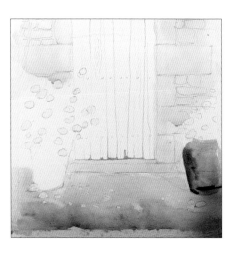

4 Mix burnt sienna and burnt umber and stipple the lower half of the gravel, working wet in wet.

5 Use the medium detail brush to paint a pale wash of burnt sienna on the right-hand plant pot.

6 Shade the left-hand side of the pot wet in wet with shadow.

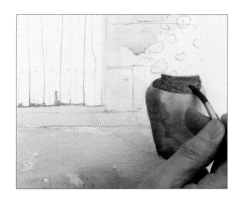

7 Paint the glazed part of the pot using a stronger mix of burnt sienna. Allow it to dry.

8 Paint shadow colour under the rim of the pot.

9 Paint the second pot with a stronger mix of burnt sienna than the first, still using the medium detail brush.

10 Drop raw sienna into the sunlit side of the pot, wet in wet. This will push the other colour away creating an interesting textural effect.

11 Drop shadow colour into the left-hand side of the pot, still working wet in wet.

12 Begin creating the foliage on the climbing plant by stippling on sunlit green paint with the golden leaf brush.

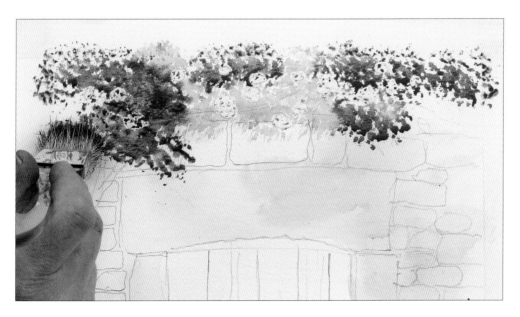

13 Continue stippling on foliage wet in wet, adding country olive.

21

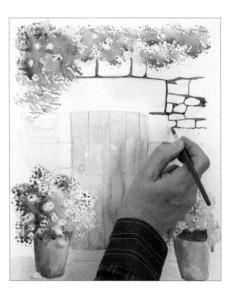

14 Paint the foliage in the pots in the same way, starting with sunlit green on the right-hand side, then adding midnight green on the left.

15 Use the large detail brush to apply a cobalt blue wash to the door. Paint roughly to suggest an old, rustic door.

16 Change to the medium detail brush and paint the outlines of the stones with a mix of burnt sienna and shadow.

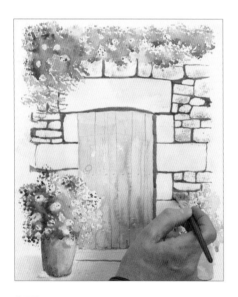

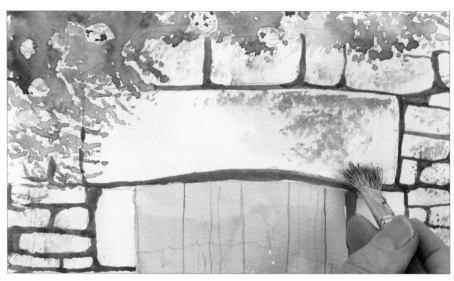

17 Use the foliage brush to stipple texture on to the stonework with burnt sienna.

18 Stipple texture on to the large stone above the door in the same way with the colour shadow.

19 Still using the colour shadow, shade the undersides and left-hand sides of the stones.

20 Mask off the ground in front of the doorstep and stipple texture on to the riser of the step.

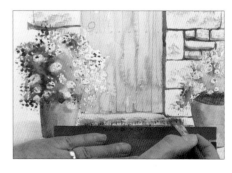

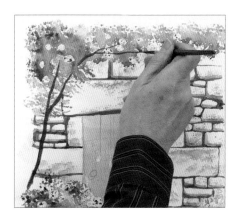

21 Paint in the stem of the vine with the medium detail brush and a strong mix of country olive and burnt umber.

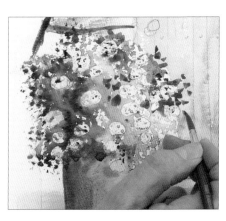

22 Add detail to the pot plants with a few brushstrokes for the outer leaves, using the medium detail brush and country olive.

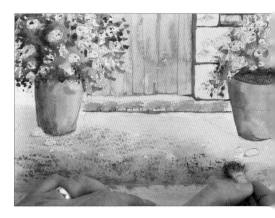

23 Use the foliage brush and burnt sienna to stipple texture on to the gravel.

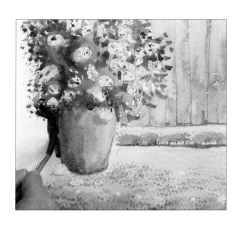

24 Add a deep shadow behind the left-hand pot using the medium detail brush and shadow mixed with burnt sienna.

25 Use the same mix and the tip of the brush to paint shadows under the stones.

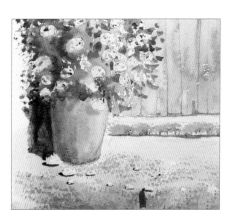

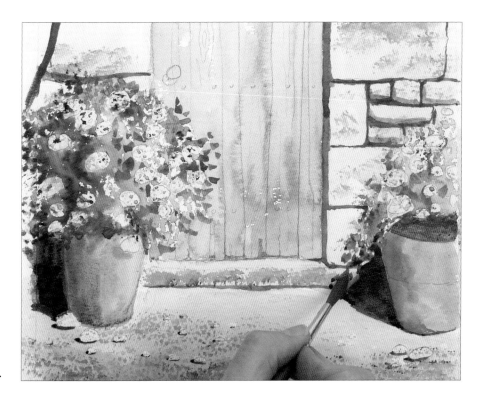

26 Paint a shadow to the left of the right-hand pot.

27 Paint shadows under the vine, reflecting the shapes of the foliage.

28 Use the large detail brush to add leaf shapes to the foliage on the vine with midnight green.

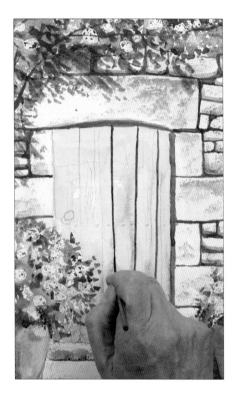

29 Paint in the panels on the door using the half-rigger and shadow mixed with cobalt blue.

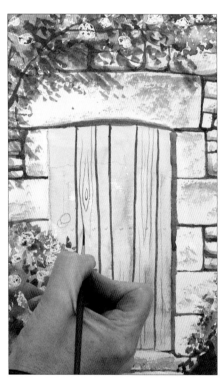

30 Use a pale mix of shadow to paint the grain of the wood.

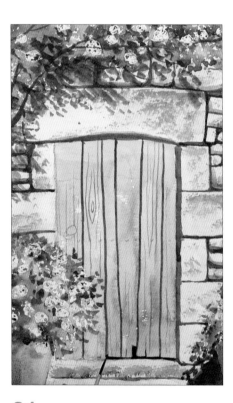

31 Mix ultramarine and burnt umber to paint the dark details at the bottom of the door.

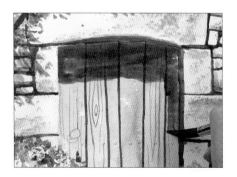

32 Use the cobalt blue and shadow mix with the large detail brush to paint the shadow on the door.

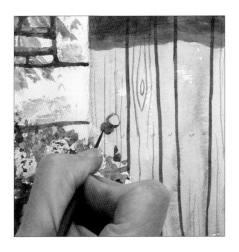

33 Use the same colour and the half-rigger to paint the doorknob.

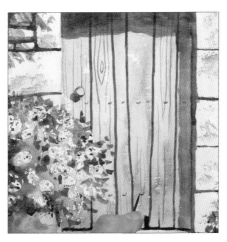

34 Paint in rows of rivets.

35 When the painting is dry, rub off all the masking fluid with clean fingers.

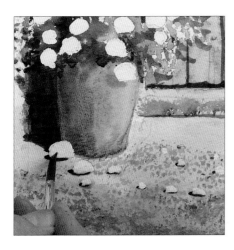

36 Paint a light wash of raw sienna over the stones with the medium detail brush.

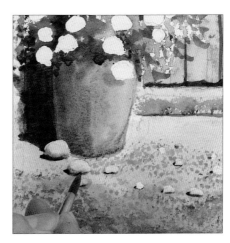

37 Drop in shade on the bottom and left-hand sides of the stones using a stronger mix of raw sienna and burnt sienna.

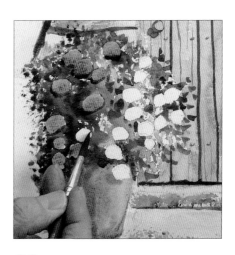

38 Paint a pale wash of permanent rose over the flowers using the medium detail brush and allow it to dry.

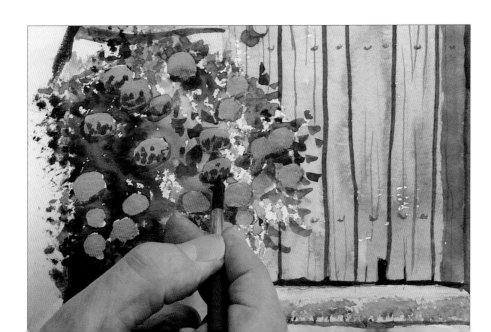

39 Make a stronger mix of permanent rose and painting wet on dry, add shade and texture on the bottom halves of the flower heads.

25

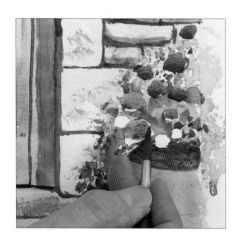 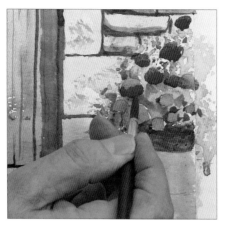

40 Paint a light wash of cadmium red over the flowers in the right-hand pot.

41 Drop in a stronger mix at the bottom, wet in wet this time.

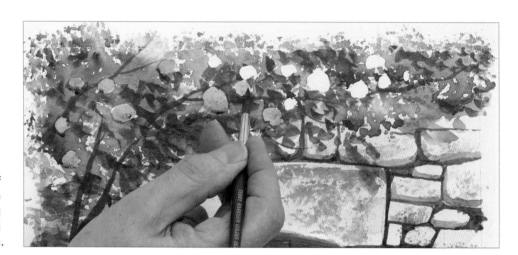

42 Paint a light wash of permanent rose over the flowers of the climbing plant, using the medium detail brush.

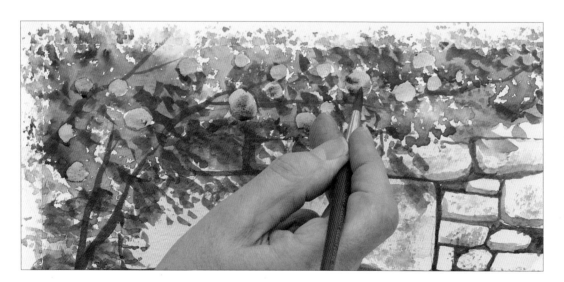

43 Drop in a mix of cobalt blue and permanent rose wet in wet on the lower parts of the flowers.

Opposite

The finished painting, reduced in size.

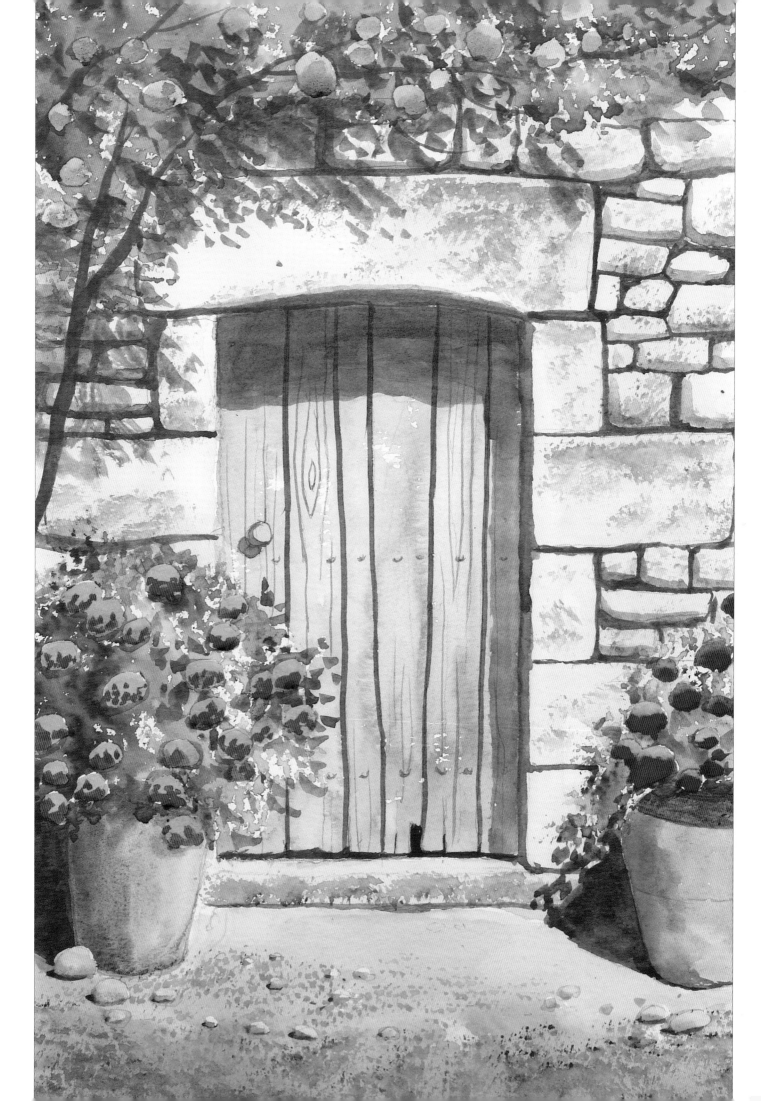

Bluebell Woods

Bluebell woods have a mystique about them, which makes them so appealing to paint. Bluebells bloom for such a short period of time, but our memories of a walk in a bluebell wood remain for a lifetime. To capture that mood is a bonus for an artist. I hope this demonstration will bring back happy memories.

You will need

300gsm (140lb) Rough watercolour paper

Masking tape

Colours: cobalt blue, cadmium yellow, sunlit green, midnight green, permanent rose, country olive, raw sienna, burnt umber, burnt sienna, shadow

Brushes: golden leaf, foliage, wizard, half-rigger, fan stippler, medium detail, large detail, fan gogh

1 Transfer the image and apply masking tape to the edges. Use the golden leaf brush to stipple on a light cobalt blue mix.

2 Add cadmium yellow, working wet in wet.

3 Still working wet in wet, stipple sunlit green mixed with cobalt blue on top.

4 Add more cobalt blue and sunlit green along the bottom.

5 While the painting is still wet, stipple on midnight green mixed with cobalt blue.

6 Mix a light bluebell-coloured wash using permanent rose and cobalt blue and apply it to the background first using the foliage brush.

7 Working quickly wet in wet, apply a slightly stronger mix of the bluebell colour further forwards.

8 Stipple on a stronger mix still further forwards, leaving gaps as shown. Allow to dry.

9 Stipple on a light mix of sunlit green wet on dry between the blue. Then add country olive wet in wet.

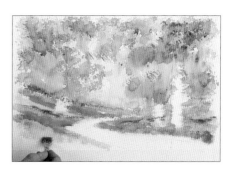

10 Add a mix of raw sienna and sunlit green towards the foreground.

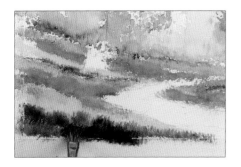

11 Stipple on midnight green at the bottom of the painting.

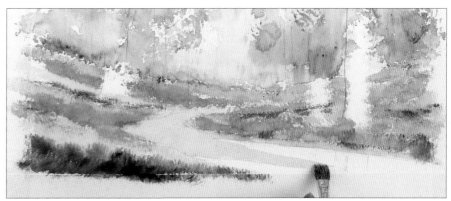

12 Use the wizard brush and raw sienna to paint the footpath, making it light in the distance and stronger further forwards.

13 Change to the half-rigger and mix cobalt blue with sunlit green to paint the distant trees. Use the outline as a guide if your original pencil lines have been obscured by paint.

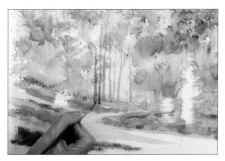

14 Paint the trees slightly further forwards, starting lower down and using a mix of cobalt blue and country olive.

15 Next paint the trees in the middle ground with a mix of country olive and burnt umber.

16 Make a darker mix of the same colours and paint the left-hand sides of the middle ground trees to create the illusion of light coming from the right. Continue adding trees and shading the left-hand sides.

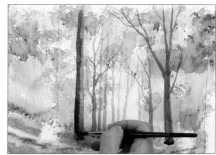

17 Make a dark mix of country olive and burnt umber and use the fan stippler to stipple ivy on to the main left-hand tree. Push the brush into the paper.

18 Paint the rest of the trunk and the branches with country olive and burnt umber and the medium detail brush.

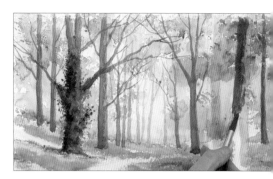

19 Take the large detail brush and a mix of raw sienna and sunlit green to paint the right-hand sides of two trees on the right.

20 Add branches using the same colour mix.

21 Paint the puddle area with a thin wash of cobalt blue and the medium detail brush. Allow it to dry.

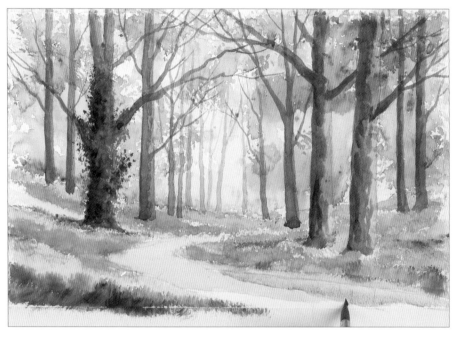

22 Paint the reflections of trees with country olive for the shaded sides and sunlit green for the right-hand sides.

23 Paint the reflections of distant trees with a very pale mix of cobalt blue and country olive.

24 Mix cobalt blue and permanent rose and add texture by stippling into the areas of bluebells beneath the trees.

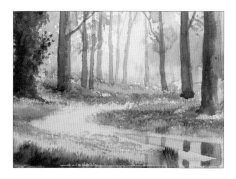

25 Use the foliage brush and a thin mix of burnt sienna to paint texture on the path.

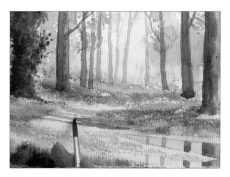

26 Change to the medium detail brush and use a thin mix of shadow to paint tree shadows across the path.

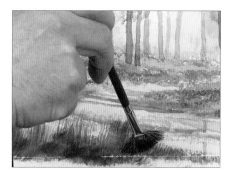

27 Load the fan gogh brush with a dry mix of midnight green and flick up grasses on the bottom left of the painting.

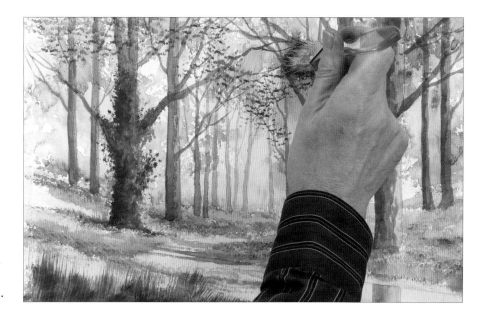

28 Load the golden leaf brush with a dry mix of country olive and stipple more foliage at the top of the painting.

29 Use the fan gogh brush to stipple midnight green paint under the trees.

Overleaf

The finished painting.

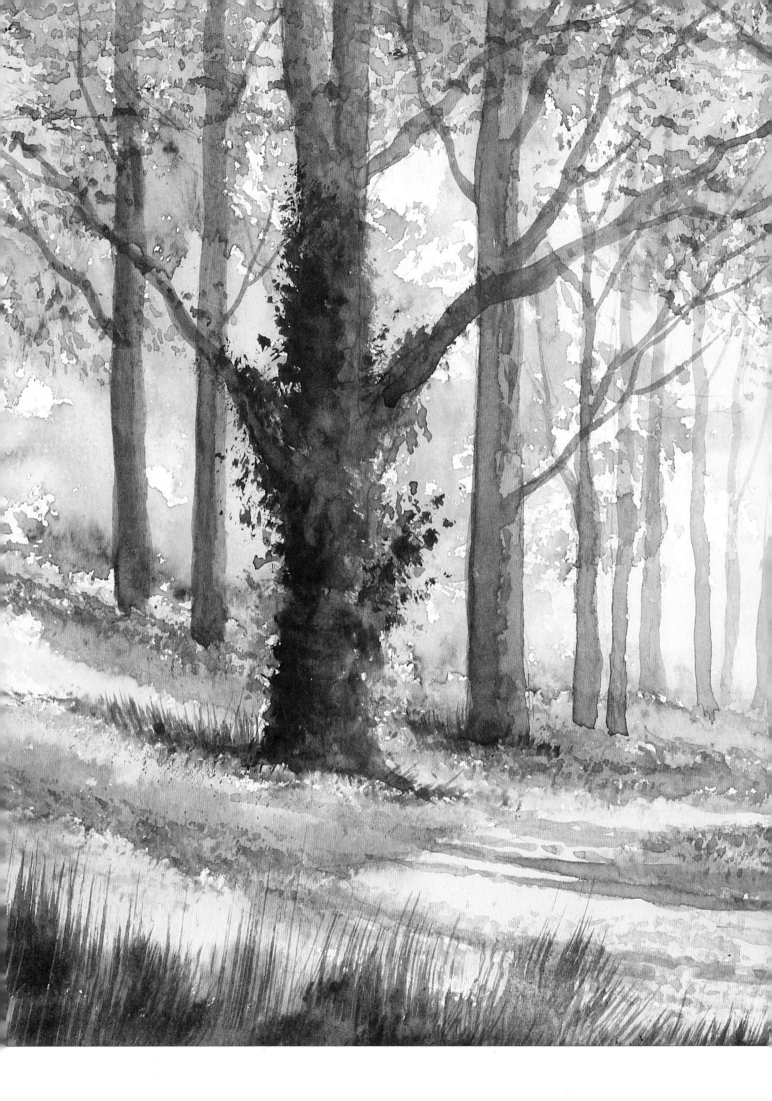

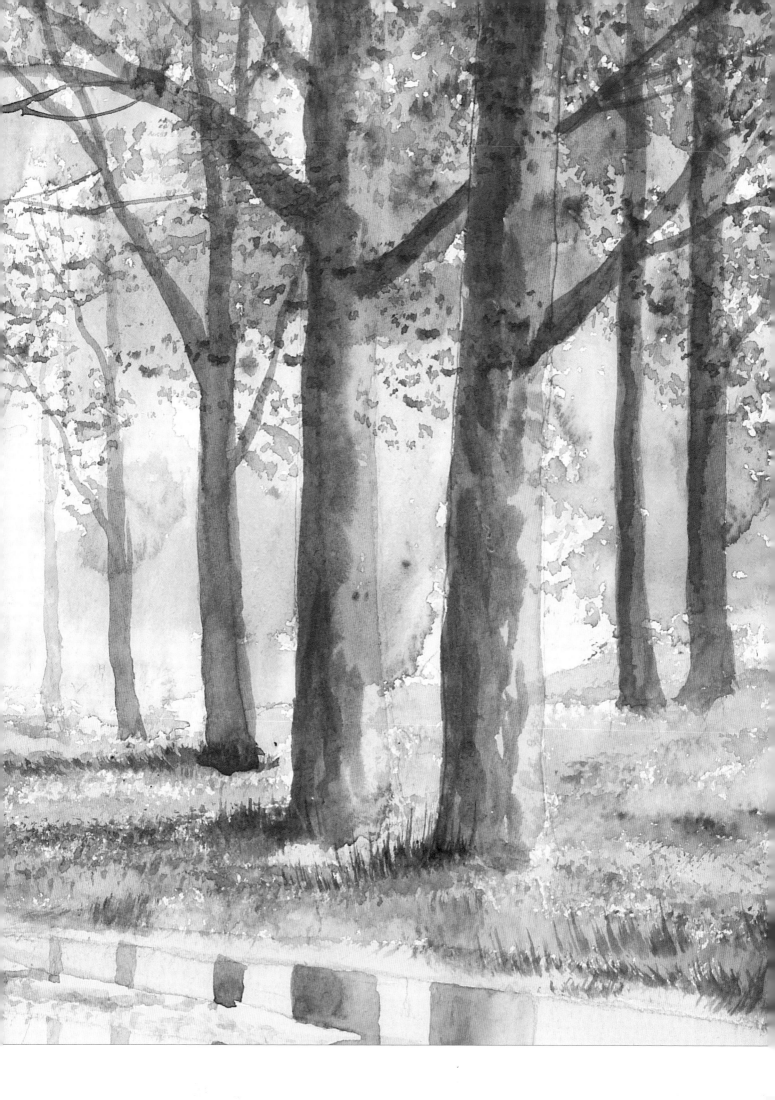

Footbridge in the Woods

This subject captures the moment when, while out walking in the woods, you happen on a tranquil scene, interrupted only by the sound of birds and rippling water. Then you whip out your paints and dash off a masterpiece! Seriously, this scene has a strong focal point and the composition leads you through the picture and off into the distance.

You will need

300gsm (140lb) Rough watercolour paper

Masking tape

Masking fluid, brush and soap

Ruling pen

Colours: cobalt blue, midnight green, sunlit green, raw sienna, cadmium yellow, country olive, burnt sienna, burnt umber, ultramarine, permanent rose, yellow ochre

Brushes: golden leaf, foliage, wizard, medium detail, half-rigger, 19mm (¾in) flat, fan gogh

Kitchen paper

Magazine page

1 Transfer the scene from the outline and mask the edges with masking tape. Paint masking fluid on the trees, flowers, bridge and bridge reflection.

2 Use the ruling pen and masking fluid to mask the grasses and the stalks of the cow parsley.

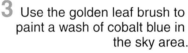

3 Use the golden leaf brush to paint a wash of cobalt blue in the sky area.

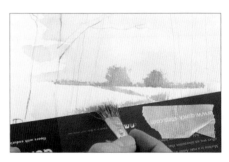

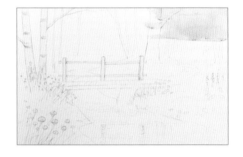

4 Scrunch up a piece of kitchen paper and use it to lift out colour from the wet wash to create clouds.

5 Mask off the horizon with a magazine page and use the foliage brush and diluted midnight green to stipple on a hedge and trees.

6 Use the magazine page at different angles to create more hedgerows coming forwards.

7 Paint the fields with pale washes of midnight green on the left and sunlit green on the right.

8 Paint the next field with a thin wash of raw sienna.

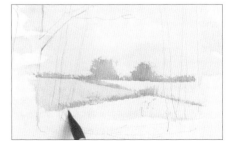

9 Take the golden leaf brush and a mix of cobalt blue and sunlit green and stipple in the foliage, leaving a gap in the middle. Then stipple cadmium yellow and fill the gap.

10 Stipple country olive over the masked silver birch trees and on the right.

11 Change to the wizard brush and paint country olive down to the water's edge.

12 Mask off the footbridge with a magazine page and use the golden leaf brush with raw sienna and sunlit green to stipple foliage above it.

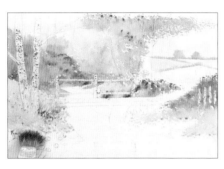

13 Stipple with sunlit green on the grassy banks of the stream.

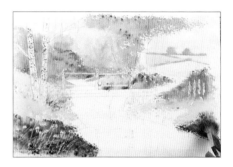

14 Paint midnight green mixed with country olive over the foreground on the right and left of the stream. Allow to dry.

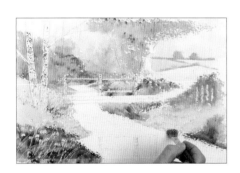

15 Use the foliage brush with raw sienna to paint the sunlit areas on either side of the stream, working wet on dry.

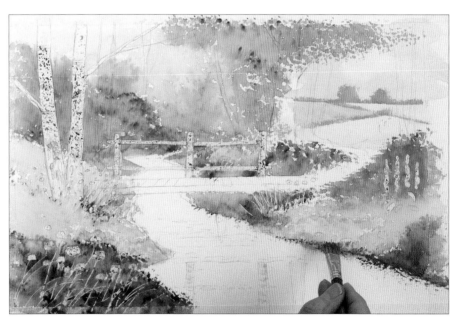

16 Drop in burnt sienna wet in wet along the water's edge.

17 Now that the background is dry, stipple on a dry mix of country olive with the golden leaf brush to build up the distant foliage.

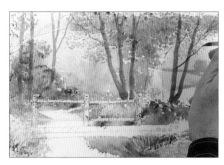

18 Use the medium detail brush and burnt umber mixed with country olive to paint the distant trees.

19 Paint the large tree trunk on the right with a mix of raw sienna and sunlit green.

20 Paint the shaded side of the tree wet in wet using burnt umber and country olive. Add texture.

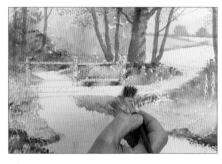

21 Paint the footpath up to the bridge with the wizard brush and raw sienna.

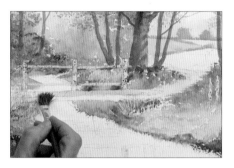

22 Add burnt umber to the mix to paint the footbridge itself.

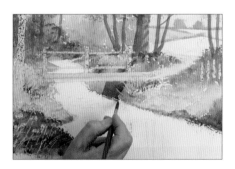

23 Use the medium detail brush to paint country olive under the bridge. Allow it to dry.

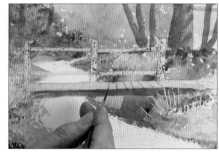

24 Paint the front of the footbridge with a mix of burnt umber and country olive, then change to the half-rigger to paint the planking.

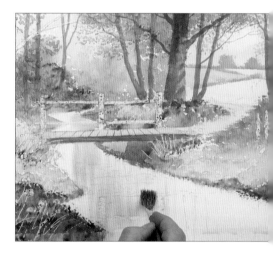

25 Wet the stream area with clean water and then pick up cobalt blue and country olive on the wizard brush and drag it downwards.

26 Make a greener mix of country olive with a touch of cobalt blue and drag it down the water area wet in wet.

27 Add cobalt blue and then midnight green on the right, dragging down the colours wet in wet.

28 Take the 19mm (¾in) flat brush and country olive and paint the reflection of the bridge with a side to side motion.

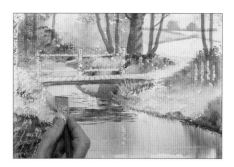

29 Make a light mix of cobalt blue and country olive and paint the smaller ripples.

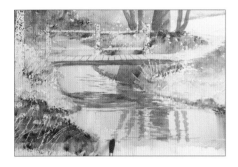

30 Paint reflections of trees using the medium detail brush and country olive with burnt umber.

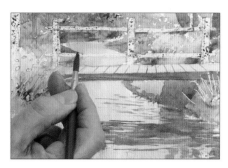

31 Use country olive to darken the stream bank, highlighting the contrast with the water.

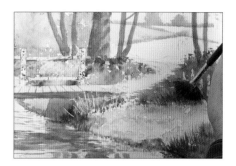

32 Change to the fan gogh and create areas of darkness under the silver birch and behind the foreground flowers by flicking up grasses with country olive.

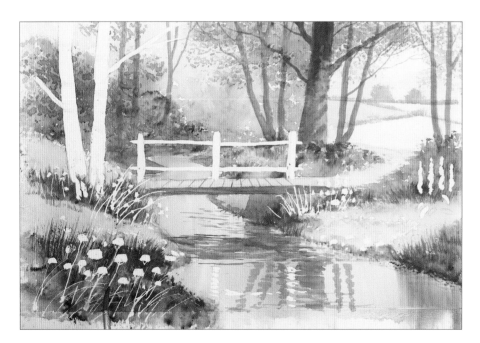

33 Remove the masking fluid by rubbing with clean fingers. Paint the grasses and stems with sunlit green and the medium detail brush.

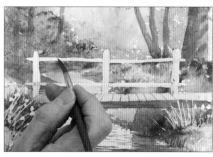

34 Paint the bridge rails with a thin mix of raw sienna and burnt umber.

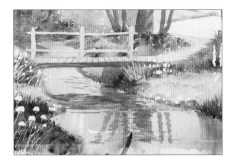

35 Paint the reflection of the bridge with the same colour.

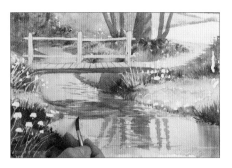

36 Use burnt umber and country olive for the reflection of the front of the bridge.

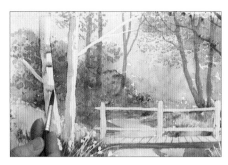

37 Paint the left-hand side of the silver birch with a mix of cobalt blue and a little burnt umber. Make horizontal brush strokes to suggest the patchy bark.

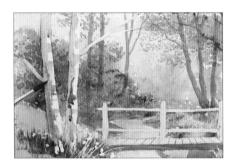

38 While the paint is wet, drip in burnt umber. Allow to dry.

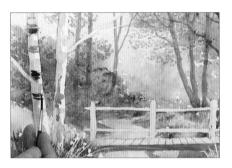

39 Mix ultramarine and burnt umber. Hold the half-rigger almost flat and drag it sideways wet on dry to produce the ragged markings on the bark.

40 Paint the fine branches with the same brush and colour.

41 Mix burnt umber and country olive and use the medium detail brush to shade the bridge posts and rails.

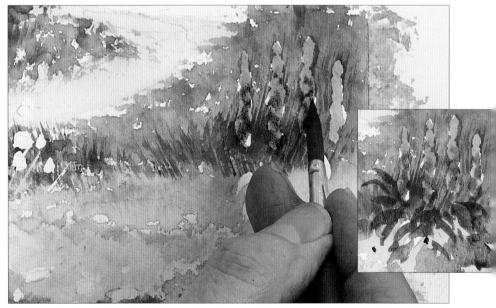

42 Paint the foxgloves with a permanent rose wash, then while this is wet, drop in a touch of cobalt blue and permanent rose. Paint the leaves with midnight green.

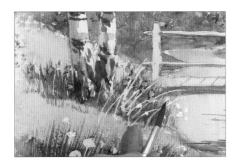

43 Use permanent rose for the middle ground flowers.

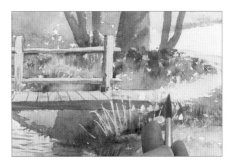

44 Paint the flowers to the right of the footbridge with cadmium yellow.

45 Make a thin mix of yellow ochre and touch it in to the shaded sides of the cow parsley flowers, leaving some white.

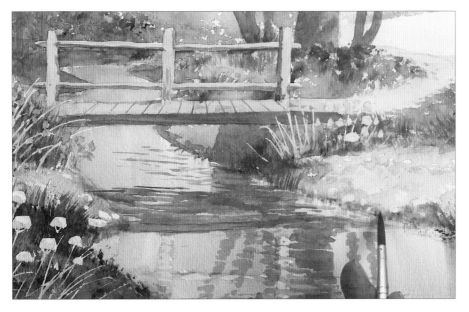

46 Paint raw sienna over the white parts left on the bank.

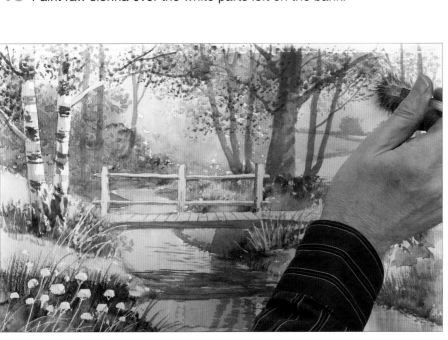

47 Add a few grasses using the half-rigger and midnight green.

48 Pick up a little country olive on the golden leaf brush and lightly stipple foliage at the top of the painting.

Overleaf

The finished painting.

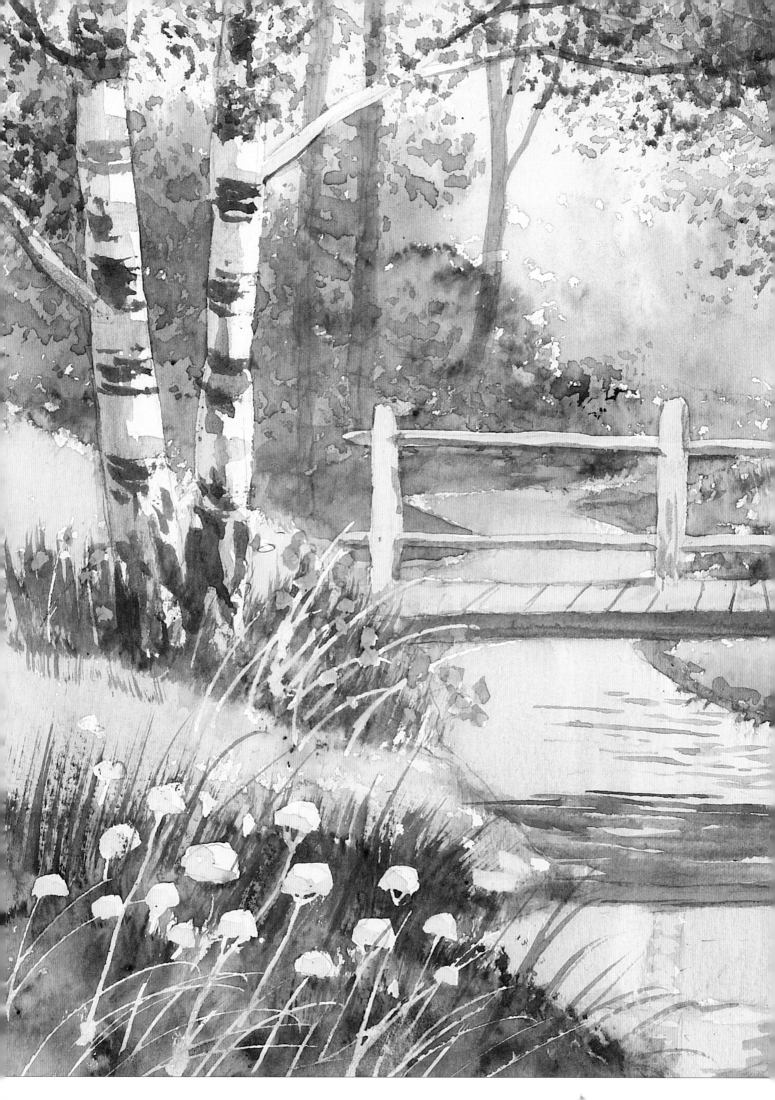

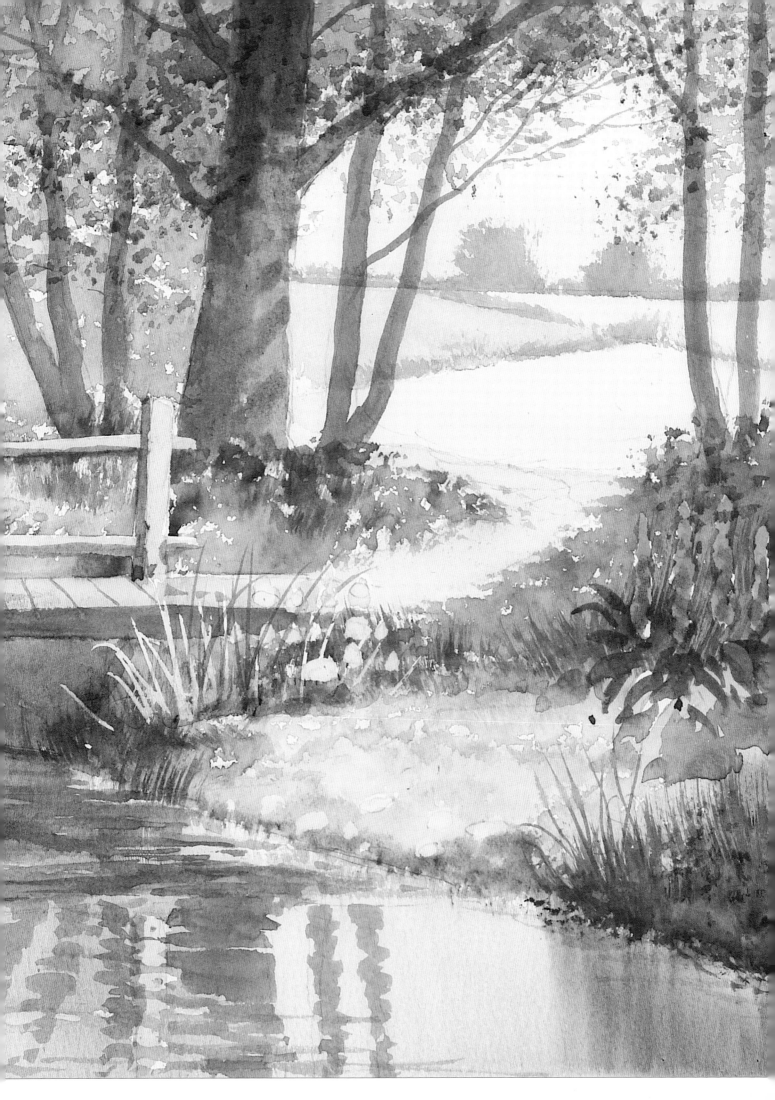

Village in the Snow

I have chosen to paint this snow scene at sunset. The reason for this is that I am not a fan of cold, moody paintings. I much prefer warm, friendly and inviting subjects. The post box adds a splash of strong colour in the foreground, emphasising the warm colour range of the scene.

You will need

300gsm (140lb)
Rough watercolour paper

Masking tape

Masking fluid, brush and soap

Ruling pen

Colours: cadmium yellow, permanent rose, cadmium red, cobalt blue, shadow, alizarin crimson, burnt sienna, burnt umber, ultramarine, midnight green, Hooker's green, country olive

Brushes: golden leaf, medium detail, small detail, fan stippler, half-rigger

Small coin

Kitchen paper

1 Transfer the image on to watercolour paper and mask off the edges with masking tape. Use masking fluid on a brush to mask the roof and branches, the top of the post box and the wall. Then use a ruling pen to mask the grasses and wire.

2 Wet the sky area with the golden leaf brush and clean water. Then paint on a wash of cadmium yellow with a touch of permanent rose.

5 Still working quickly wet in wet, paint a wash of cobalt blue across the top of the sky.

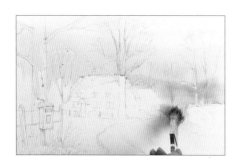

3 Add cadmium red, working wet in wet.

4 Paint a very pale wash of cadmium red wet in wet across the middle of the sky.

6 While the paint is wet, drop in the colour shadow to create clouds.

7 Wrap a small coin in kitchen paper as shown and press it against the paper where you want the sun to be.

8 Lift the wrapped coin to reveal a pale sun.

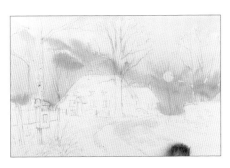

9 Make a very pale wash of permanent rose and cadmium yellow and paint the sky colours reflected in the snow.

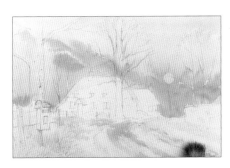

10 Touch in shadows wet in wet with a mix of cobalt blue and a little alizarin crimson.

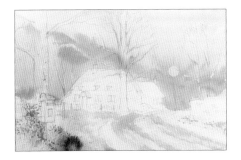

11 Still using the golden leaf brush, lightly stipple a little burnt sienna to suggest brown undergrowth. Allow to dry.

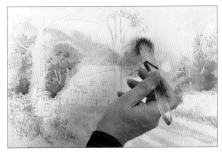

12 Use a pale mix of the colour shadow to touch in foliage in the treetops. Allow to dry.

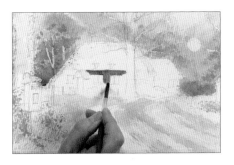

13 Paint the face of the cottage with the medium detail brush and burnt sienna.

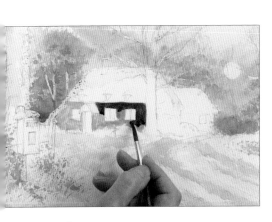

14 Drop in the colour shadow wet in wet.

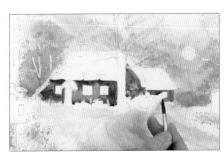

15 Use a mix of burnt umber and shadow to paint the darker side of the cottage.

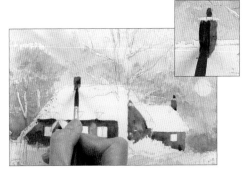

16 Paint the chimney pot with burnt umber and shadow and allow it to dry. Then paint the shaded side with a stronger mix of the same colours.

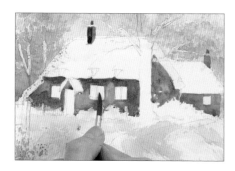

17 Paint the windows with lights on, using a thin mix of cadmium yellow.

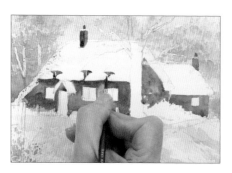

18 Paint in the architectural details with the small detail brush and ultramarine and burnt umber.

19 Use the same brush and mix to paint the dark windows.

20 Paint in the frames of the light windows.

21 Wet the wall with clean water and use the medium detail brush to paint on a wash of burnt sienna.

22 Drop in shadow colour wet in wet.

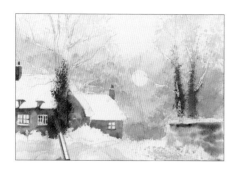

23 Use the fan stippler and midnight green with a touch of burnt umber to stipple ivy climbing the two main trees.

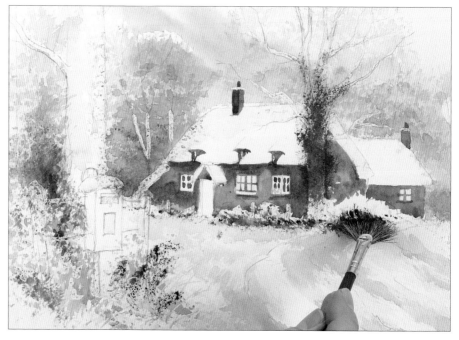

24 Use the same brush and Hooker's green to add greenery around the post box and in front of the cottage.

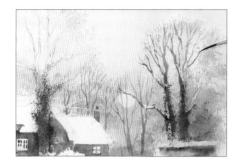

25 Use the half-rigger and a mix of burnt sienna and shadow to paint the distant trees. The twigs bring together the foliage effect and fool the eye into seeing a fine lacework of branches and twigs.

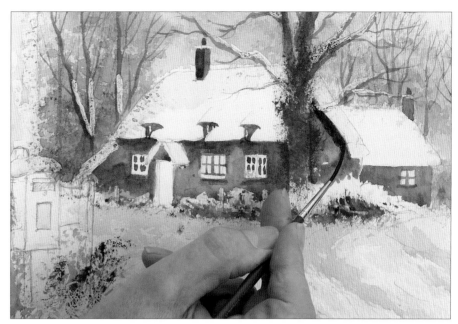

26 Paint a dark shadow under the eaves with a stronger mix of the same colours.

27 Change to the medium detail brush and paint cobalt blue down the shadowed side of a tree.

28 Paint the rest of the tree trunk and branches beneath the masking fluid with a mix of burnt umber and country olive.

29 Use the same colour to paint the posts.

30 Paint dark grasses among the masked grasses using the half-rigger and burnt umber.

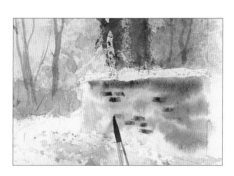

31 Paint bricks in the wall with the small detail brush and burnt sienna paint.

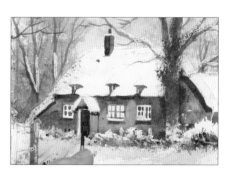

32 Paint the door and under the windowsills with burnt umber and shadow.

45

33 Change to the medium detail brush and paint the post box with cadmium red. Allow it to dry.

34 Use the small detail brush and shadow mixed with cadmium red to paint the shaded side, the shadow under the snow and the details.

35 Paint the dark of the post box with ultramarine and burnt umber.

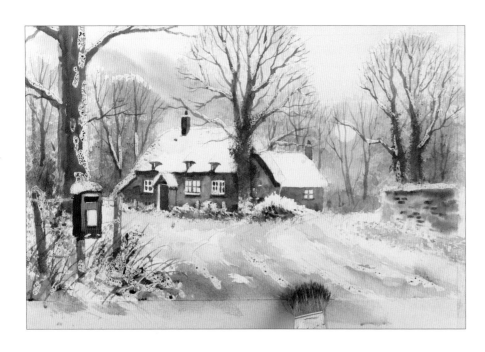

36 Paint a pale wash of shadow colour across the foreground. This prevents the eye from drifting off the bottom of the picture.

37 Rub off all the masking fluid with clean fingers. Paint the shadowed part of the snowy roof with shadow and cobalt blue and the medium detail brush.

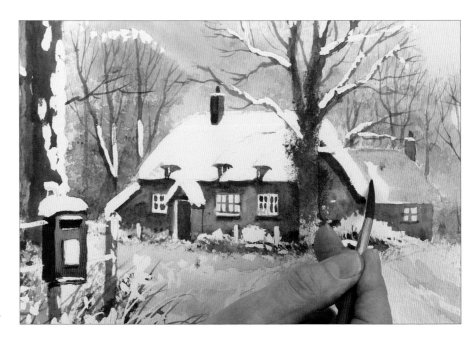

 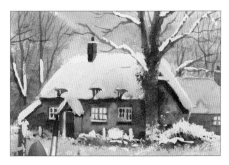

38 Make a lighter mix of the same colour and paint the front-facing roof.

39 Paint the same thin wash over the white of the window frames.

40 Use the same wash to create shadows in the snow and to shade the underside of the snow on the wall, post box and trees.

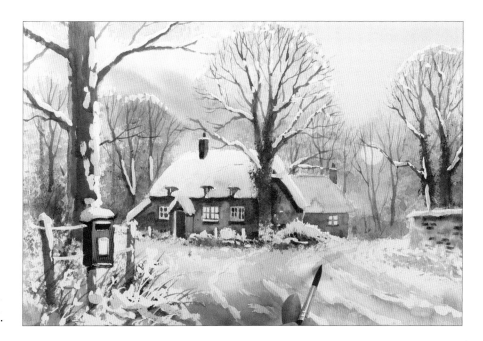

41 Add tracks on the path with a mix of cobalt blue and shadow and the medium detail brush.

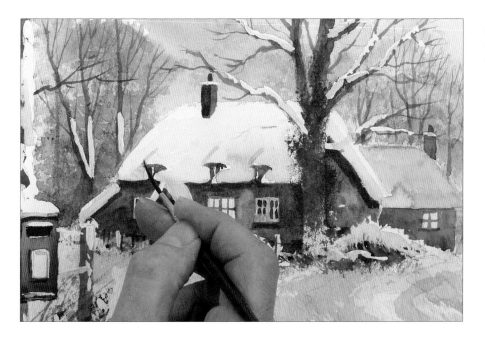

42 Mix burnt umber and shadow to paint the fence and the dormer windows with the half-rigger.

Overleaf

The finished painting.

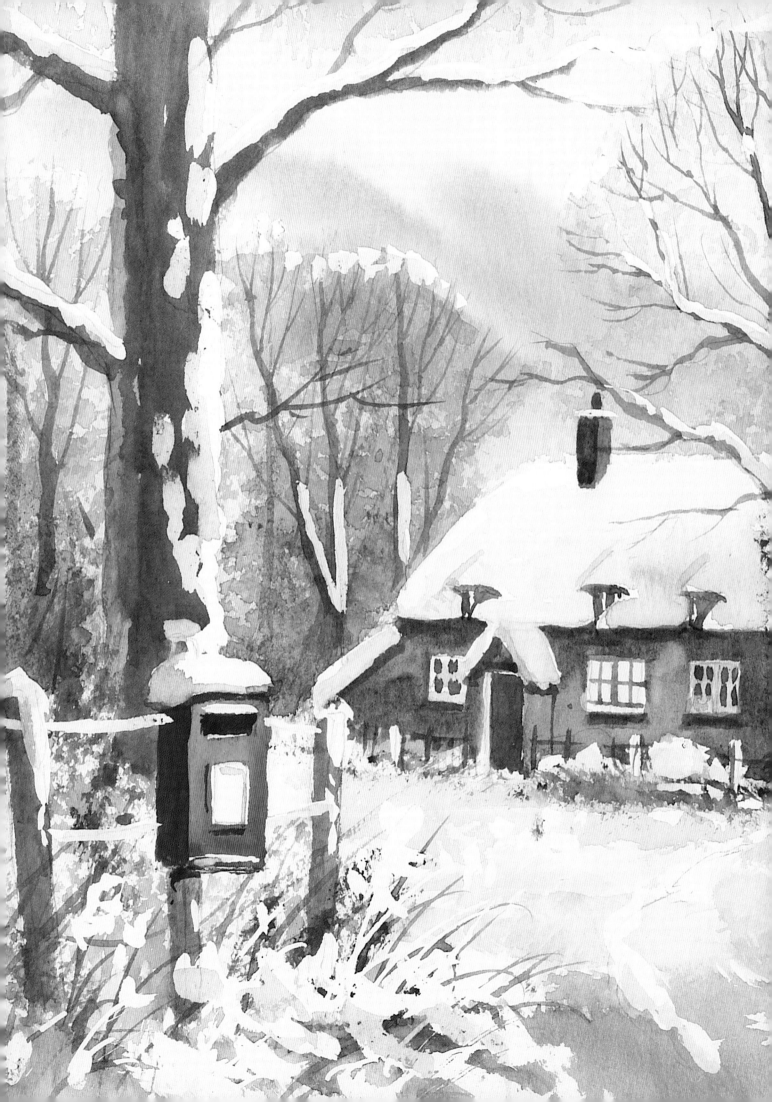

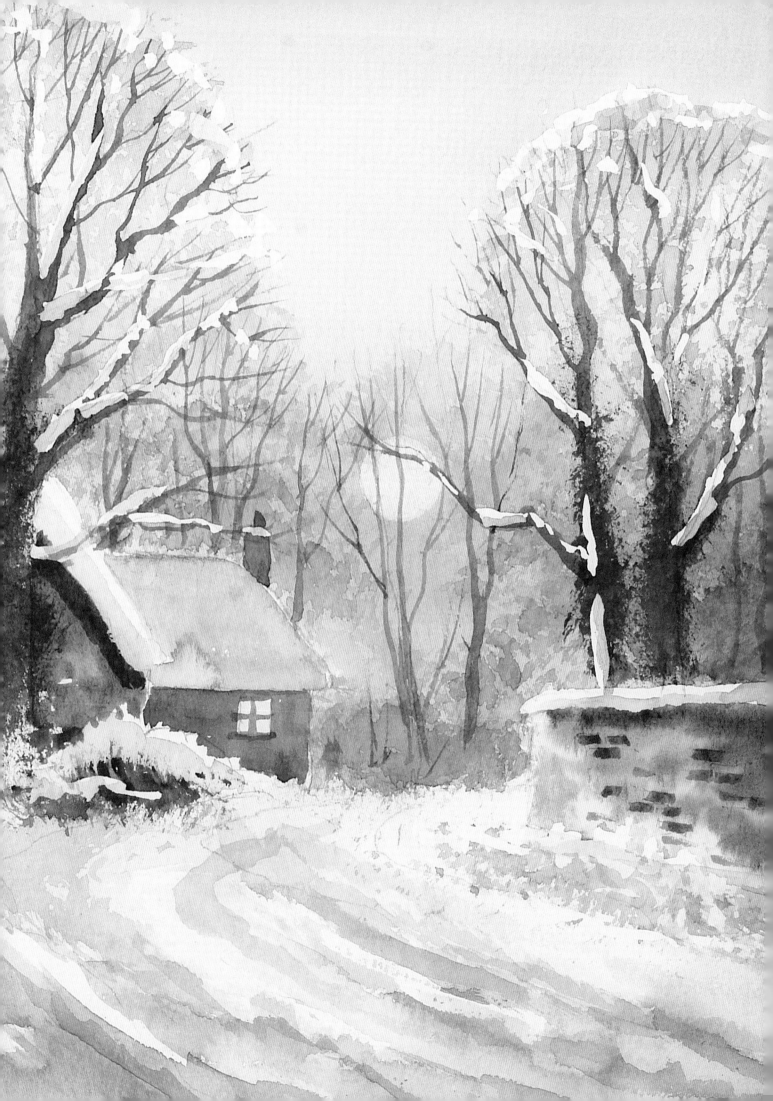

Path Through Bluebells

42 x 29.5cm (16½ x 11⁵/₈in)

I never tire of painting bluebell woods. This one features silver birch trees, and celandine flowers add a splash of yellow in the foreground.

Canal in Autumn

42 x 29.5cm (16½ x 11⁵/₈in)

The lines of the towpath, the canal and the boat all lead towards the distant bridge and its reflection, which form the focal point of this restful scene.

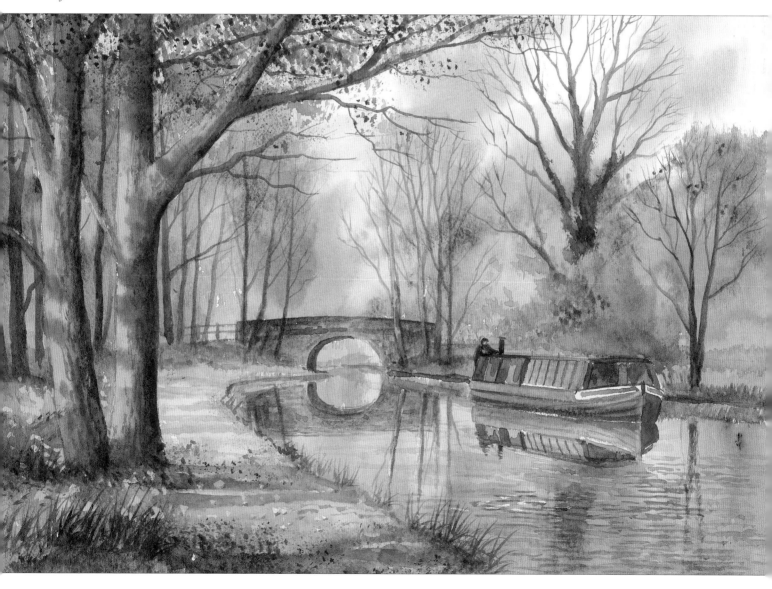

TREES & WOODLANDS

by Geoff Kersey

I have always believed in the importance of drawing and I encourage students of watercolour landscape painting to spend time practising drawing and sketching in order to develop their powers of observation and their understanding of composition and perspective. I have however learnt over the years that it helps many people to get more pleasure from their painting if they can side-step this obstacle, at least initially, and get on with the exciting part of mixing the colours, laying the washes and enjoying seeing the painting take shape. This book is designed to help you do just that. By using the outlines provided for each project, you can be sure of a sound foundation, enabling you to get straight on to creating an atmospheric landscape you can be proud to hang on your wall. After all, there are enough things in life we have to do whether we like it or not; your hobby should be fun.

Trees and woodlands are my favourite aspects of landscape painting. A walk through the woods on a crisp winter morning, the riot of autumn colour on a bright October day, or the feeling of a fresh start you get when surrounded by new, spring growth. Woodlands and trees are accessible to most of us, and they are so inspiring that after a walk like this I can't wait to get painting.

My advice when tackling these projects is to use the outlines to help you get the basic perspective, shapes and underlying composition correct, but as you paint, do not feel too restricted by the drawing. Turn it into your own painting. Make changes if you wish, by adding figures, or moving a tree or two. I deliberately have not drawn every little detail or every branch, to encourage you to make a few decisions of your own and gradually gain an instinct for what works. Above all enjoy it.

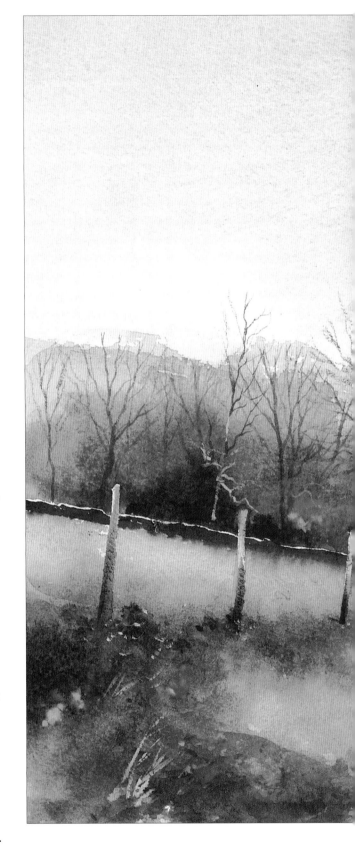

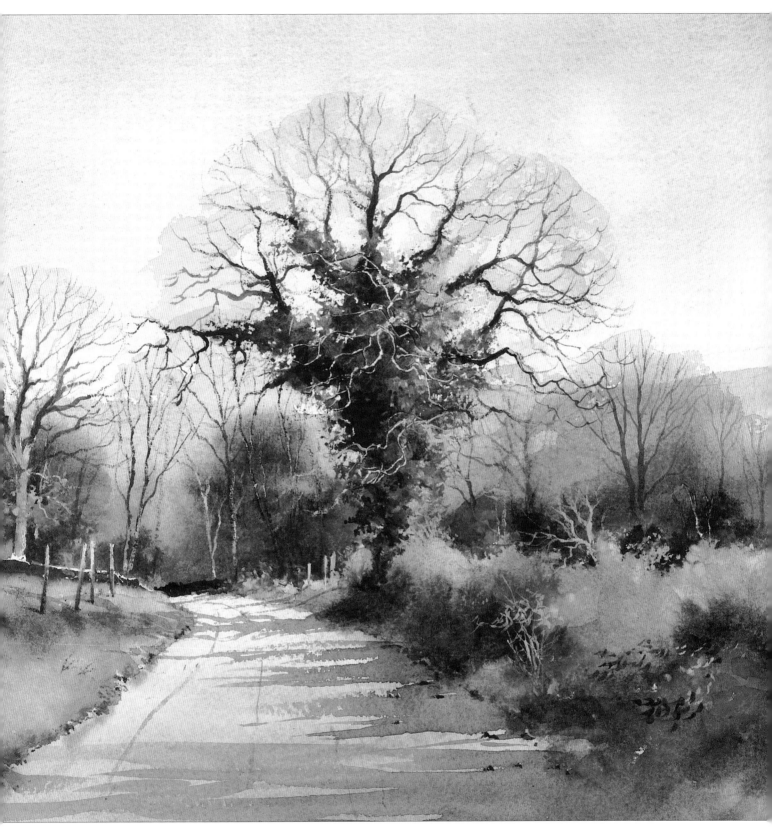

The Road from Stanton Lees

41.2 x 28.2cm (16¼ x 11⅛in)

I came across this scene on a New Year's Day walk (I always carry my camera) and was immediately struck by the shape of the tall ivy-clad tree which dominates the scene. I have reduced the size of the main tree on the left of the road to create a more pleasing composition. Note how the purple shadows create a contrast with the warm browns and yellows, particularly in the hedgerow on the right.

TRACING

8

Snow Scene

We had a light fall of snow in January of this year which thawed within twenty-four hours, so I was pleased that I had been able to seize the opportunity and get out there with the camera to find some subjects. I have tried here to capture that feeling of a crisp, fresh fall of snow on a bright winter morning.

You will need

300gsm (140lb) Rough watercolour paper, 56 x 38cm (22 x 15in)

Masking fluid

Kitchen paper

Colours: cobalt blue, rose madder, raw sienna, burnt sienna, Naples yellow, aureolin, viridian, ultramarine blue, white gouache

Brushes: no. 16, no. 10, no. 8, no. 1 and no. 4 round

1 Transfer the image on to the watercolour paper. Apply masking fluid to the line where the woodland floor meets the distant trees, and on some trees and rocks as shown.

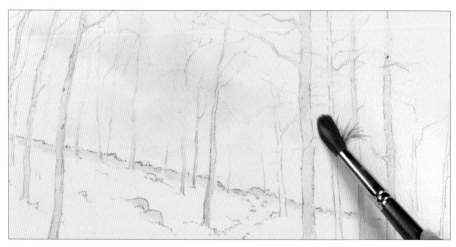

2 Mix two thin washes for the sky: cobalt blue for a cold blue and cobalt blue with rose madder for a warmer blue. Also make a mix for the distant trees from raw sienna and burnt sienna; another mix of Naples yellow and burnt sienna; and a dark brown from burnt sienna and cobalt blue. Wet the area above the ground with clean water. Using a no. 16 brush, pick up the cobalt blue wash and lay it into the sky. Work wet in wet from now on.

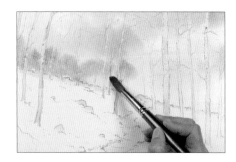

3 Paint the warm blue from the top of the sky, leaving some white showing. Use the same mix to paint a background for the distant trees.

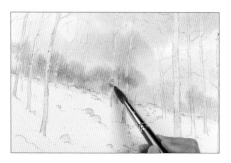

4 Working quickly, float the raw sienna and burnt sienna mix into the warm blue while it is wet so that the distant trees will look soft and diffused.

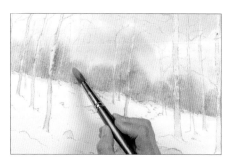

5 Next, float the Naples yellow and burnt sienna mix into the wet background.

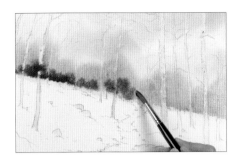

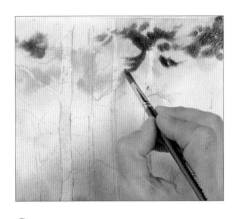

6 Change to the no. 10 brush and wait until the shine is just going off the paper to paint the base of the distant trees with the dark brown mix. Waiting should prevent the dark brown from spreading too far into the lighter paint.

Tip

If the dark brown floats too high, prop up the top of the painting board to stop it spreading further.

7 Allow the painting to dry before working on the firs on the right. Make a light green mix of aureolin and cobalt blue and a thicker mix of viridian, utramarine blue and burnt sienna, the consistency of single cream. Re-wet the top right-hand side of the painting with clean water. Wet a larger area than you will need to avoid hard lines forming later. Use the no. 8 brush and the light green mix to brush in the shapes of the firs.

8 Working wet in wet, suggest the edges of the foliage with the dark green mix on the point of the brush.

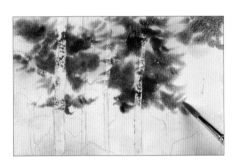

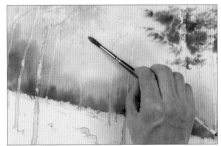

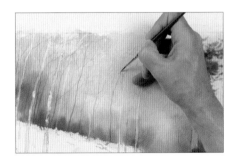

9 Still working on to the wet background, make larger marks with the no. 10 brush and then continue with the no. 8 for more detailed work. Allow the painting to dry.

10 Clean the no. 8 brush and pick up a mix of cobalt blue and rose madder. Use the dry brush technique to paint a background for the trees on the left of the painting.

11 Mix cobalt blue, rose madder and burnt sienna for the distant trees. Use the no. 1 brush to add fine trunks and branches, working from left to right and varying the mix by adding water to make some trees look further away.

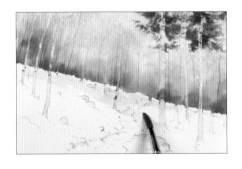

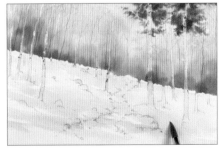

12 Remove the masking fluid from the ground only. Use the no. 16 brush to paint a wash of cobalt blue in the distance, leaving white at the top edge. Soften the lower edge with water.

13 Paint a warmer mix of cobalt blue and rose madder in the foreground. Your brush strokes should follow the sloping shape of the land.

14 Mix cobalt blue and burnt sienna and use the no. 4 brush and the dry brush technique to paint stones showing through the snow. Leave bits of white for snow.

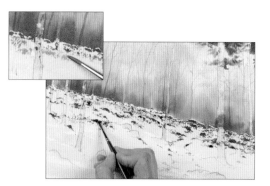

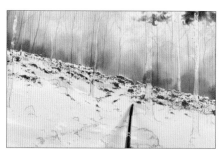

15 Do more dry brush work with a mix of aureolin and cobalt blue to suggest grass growing through the snow. Change to the no. 8 brush and make larger marks towards the foreground to create perspective.

16 Use a mix of cobalt blue and rose madder on the no. 8 brush to paint in shadow on the snowy ground. Soften the edges with clean water.

17 Remove the masking fluid from some of the middle distance trees with a clean finger. Mix Naples yellow with burnt sienna and burnt sienna with cobalt blue to make light and dark tree mixes.

18 Use the no. 4 brush to paint in the light mix, then drop in the dark mix wet in wet. You can add more of the lighter colour to ensure that the colours blend to make the trunk look cylindrical.

19 Paint the fine branchwork with the no. 1 brush and the darker brown.

20 Use the darker brown to darken some of the middle distance trees and bring the trunks a little lower to make them appear further forwards.

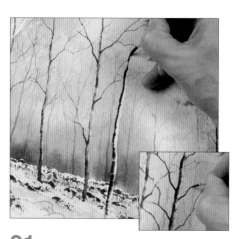

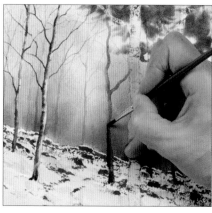

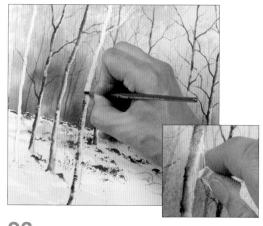

21 Paint the middle tree with clean water, then a hint of green mixed from aureolin and cobalt blue, then drop in a dark brown mix of burnt sienna and ultramarine blue. Add the branches using a no. 1 brush.

22 Begin to paint the fir tree trunks, following the pencil lines. Paint raw sienna and burnt sienna first and then drop in burnt sienna and ultramarine wet in wet so that the colours merge.

23 Remove all the remaining masking fluid. For the silver birches, mix a purple from cobalt blue and rose madder; a green from aureolin and cobalt blue and a dark brown from burnt sienna and ultramarine blue. Paint the trunk with clean water. Drop in green, then purple, wet in wet. Drop in the dark brown markings, working up the left-hand side. Use kitchen paper to lift out the dark colour if it drifts too far.

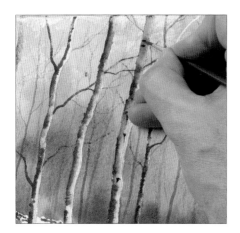

24 Use burnt sienna and ultramarine on the no. 1 brush to pick out details on the bark.

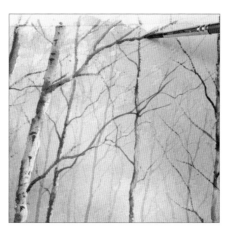

25 Using the no. 4 brush, paint the branches with green first and then drop in the dark brown wet in wet.

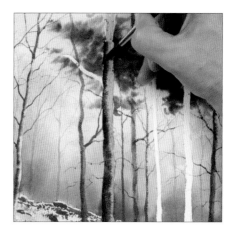

26 Work on the trunks of the fir trees on the right. Paint raw sienna and rose madder from the ground up, then drop in the dark brown mix wet in wet.

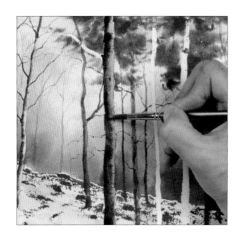

27 Drop in green mixed from aureolin and cobalt blue.

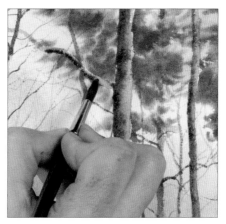

28 To paint the branch, paint raw sienna and rose madder first and then float in the dark brown on the underside.

29 Finish the branch with a no. 1 brush and the dark brown.

30 Use the no. 8 brush to dampen the area around the firs' branches with clean water. Then drop in a dark green mixed from viridian, ultramarine blue and burnt sienna. Allow the area to dry.

31 Use opaque Naples yellow, almost neat, and the no. 1 brush to paint highlighted branches over the dark foliage.

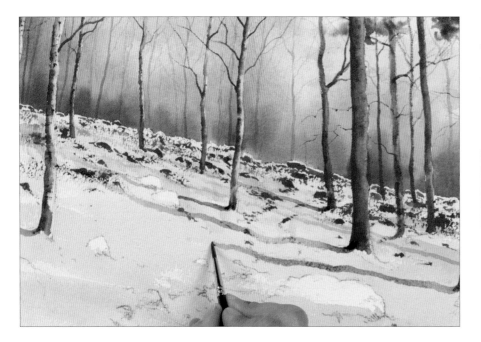

32 Use the no. 4 brush and cobalt blue with rose madder to paint shadows from the trees to suggest the shape of the hill.

Tip

Keep a careful watch over the angles of the shadows so that they remain consistent.

33 Paint stones using burnt sienna and ultramarine, leaving white paper so that they look snow-capped.

34 Mix raw sienna with burnt sienna to suggest bracken growing through the snow, and paint it with a dry no. 4 brush used on its side. Use this technique to suggest the edges of a path.

35 Paint a branch on the ground with the no. 1 brush and burnt sienna with ultramarine blue. Touch in a few blades of grass.

36 Paint more bracken as in step 34 on the other side of the path.

37 Use the no. 4 brush and a shadow mix of cobalt blue and rose madder to paint shadows on the snow-covered stones.

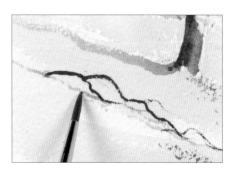

38 Add fine shadows, for instance under the branch.

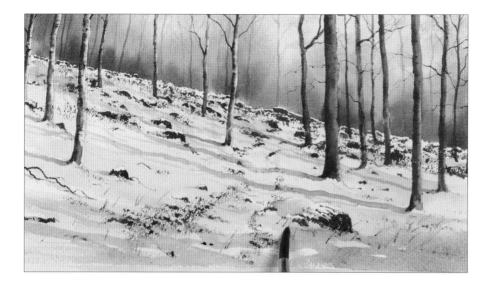

39 Use the no. 10 brush to paint shadows across the foreground from unseen trees. Dampen them in with clean water.

Tip

Take care when painting shadows not to smudge the dark pigment on the stones and rocks.

40 At this point it is a good idea to stand back from the painting and see if there are any pencil lines you have missed, or any more trees you want to add. I added some more trees in the middle distance using a mix of burnt sienna and cobalt blue with the no. 4 brush.

41 Pick up a little neat white gouache on the no. 1 brush and paint snow on top of some of the branches.

42 Use the brush on its side with the dry brush technique to suggest snow on some trunks.

Overleaf

The finished painting.

59

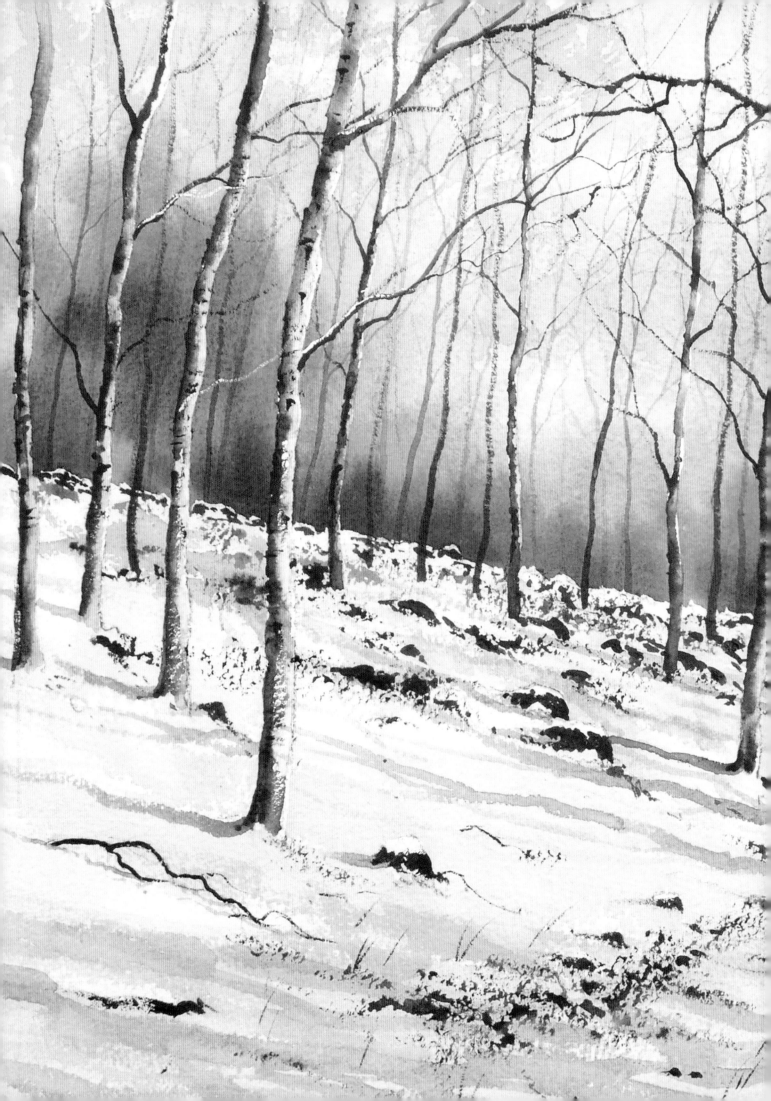

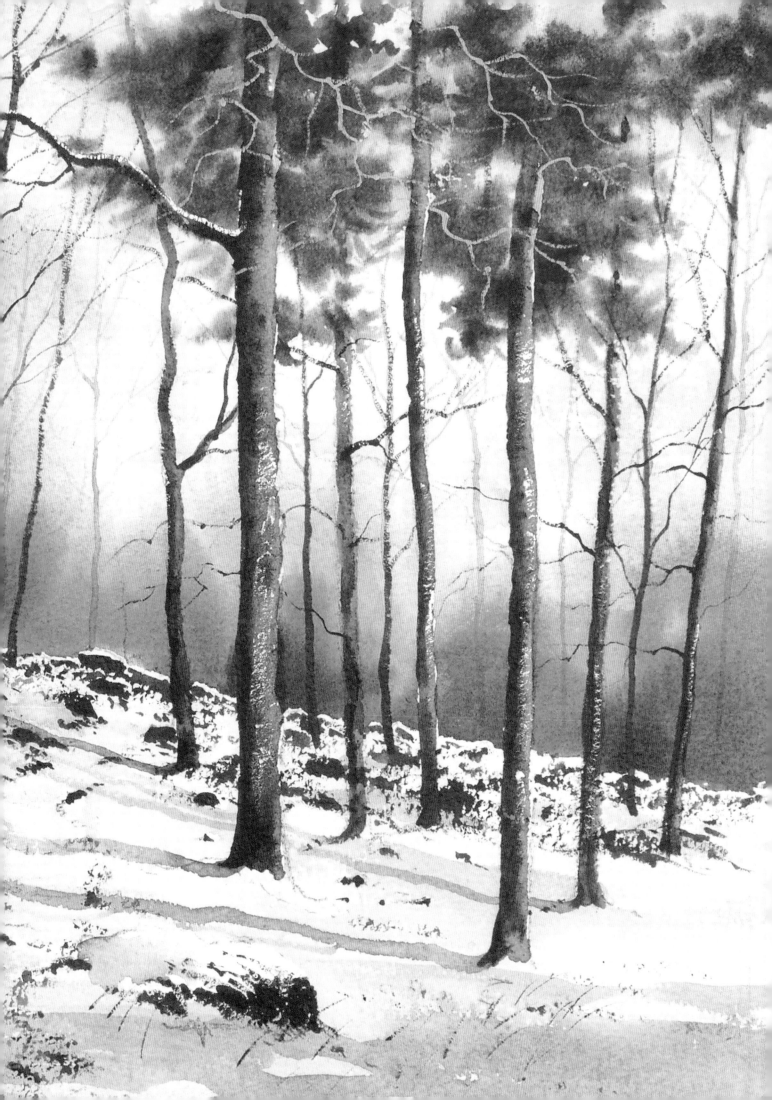

Autumn Woodland

This autumn scene gives you the chance to use a complementary colour scheme of purple and orange: a warm, purplish blue for the sky and the brown and orange tones of the foliage.

TRACING

10

You will need

300gsm (140lb) Rough watercolour paper, 56 x 38cm (22 x 15in)

Masking fluid

Colours: rose madder, ultramarine blue, aureolin, burnt sienna, raw sienna, cobalt blue, cobalt turquoise, light red, cadmium lemon, Naples yellow, viridian

Brushes: large wash brush, no. 16, no. 10 , no. 8, no. 1 and no. 4 round

1 Transfer the image on to watercolour paper. Paint masking fluid on to the edge of the ground, the trees that will catch the light and the rocks. Mix the colours you will need for the first wet-in-wet steps: a thin mix of rose madder and ultramarine blue for the sky; aureolin and burnt sienna and a richer mix of raw sienna and burnt sienna for the autumn foliage; a green from aureolin and cobalt blue and a grey-green from rose madder and cobalt turquoise; a purple-brown from ultramarine blue, light red and rose madder; and a yellow from cadmium lemon and Naples yellow. Use a large wash brush to wet down to the ground with clean water.

2 Use the no. 16 brush to wash rose madder and ultramarine blue into the top of the sky. Then drop in cadmium lemon and Naples yellow wet in wet.

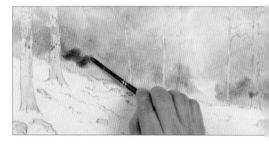

3 Paint the aureolin and burnt sienna mix down to the ground, then add the redder mix of raw sienna and burnt sienna as shown.

4 Drop in the brighter green with the no. 10 brush, then change to the no. 8 brush and dab in the grey-green mix lower down.

5 Pick up the purple-brown and paint it down near the ground with the side of the brush. Allow the area to dry.

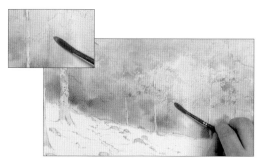

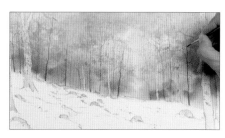

6 Use the side of the no. 8 brush and dry brush work to paint a mix of cadmium lemon and burnt sienna over the foliage area. Add a little water to vary the effect. Do the same with aureolin and cobalt blue, then with raw sienna and burnt sienna.

7 Use the no. 1 brush and a purple-grey mix of ultramarine blue, light red and rose madder to paint distant trees and branches which do not appear in the outline. Paint some broken lines and vary the thickness of the paint to suggest that some trees are further away.

8 Rub the masking fluid off the ground and the three trees in the middle distance. Paint a thin wash of Naples yellow on a trunk, then paint the purple-grey mix on the left-hand side, wet in wet.

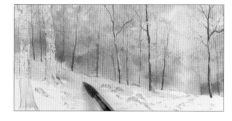

9 Add branches with the purple-grey mix and the no. 1 brush. Repeat steps 8–9 for the other two trees in the middle distance.

10 Mix colours for the ground: aureolin and burnt sienna for orange; green from aureolin and cobalt blue; purple-grey from ultramarine blue, light red and rose madder; purple from ultramarine blue and rose madder. Use the no. 16 brush to paint orange at the top of the ground, following the slope of the land.

11 Introduce purple-grey wet in wet, then green.

12 Add purple wet in wet and soften with clean water, then add more green with the no. 10 brush. Next drop in more purple-grey at the bottom.

13 Paint more orange where the woodland floor meets the path, then float in the purple-grey.

14 Still working wet in wet, drop in a grey-green mix of cobalt turquoise and rose madder. This granulates a little, creating a useful effect.

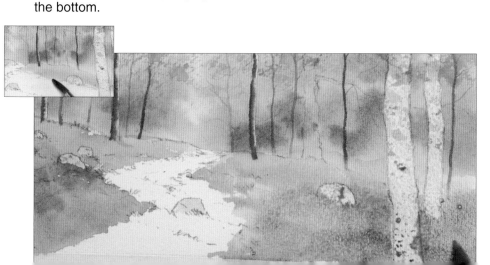

15 The right-hand side of the path had dried in a hard line so it needed to be softened with the no. 10 brush and clean water. Paint the right-hand ground in the same way as on the left, using the orange, grey-green and bright green mixes wet in wet.

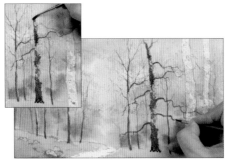

16 Using the purple-grey mix of ultramarine blue, light red and rose madder and the no. 4 brush, extend some of the trunks of the middle distance trees downwards to bring them forwards.

17 Paint the large tree on the right using a dark brown mixed from burnt sienna and ultramarine blue. Use the dry brush technique and leave gaps for foliage. Add strong branches going behind the foreground trees. Add finer branches with the no. 1 brush.

18 Add fine branches to all the trees using the no. 1 brush and a mix of ultramarine blue, light red and rose madder.

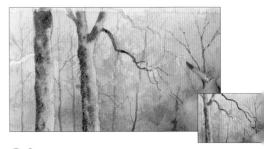

19 Remove the masking fluid from the trees on the left and mix colours for the trunks: a purple from ultramarine blue and rose madder; an orange from aureolin and burnt sienna; a dark brown from burnt sienna, ultramarine blue and rose madder and a green from aureolin and cobalt blue. Wet the trunk with clean water and drop in aureolin and burnt sienna, then purple on the left-hand side.

20 Paint shadow on the left-hand side with the dark brown mix, making sure it is uneven so that the tree looks natural. Drop in the green mix for moss on the lower trunk.

21 Paint the main branches, beginning with the aureolin and burnt sienna mix, then dropping in the dark brown wet in wet.

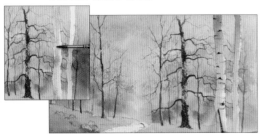
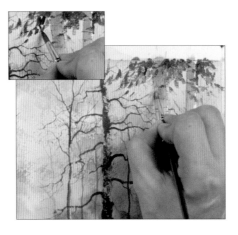
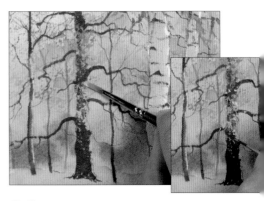

22 Remove the masking fluid from the silver birches and mix a purple from ultramarine and rose madder; an orange from aureolin and burnt sienna; and a dark brown from ultramarine blue and burnt sienna. Wet the tree, float in the purple with the no. 8 brush, then float in aureolin and burnt sienna. Paint the trunk details with the no. 1 brush and the dark brown. Complete both trees.

23 Mix a dark green from viridian, ultramarine blue and burnt sienna and paint foliage between the birches using the no. 8 brush. Next, working wet in wet, paint leaves with the no. 4 brush and a mix of cadmium lemon and burnt sienna, which gives you a more opaque orange.

24 Paint foliage over the dark tree trunk using a no. 4 brush and the cadmium lemon and burnt sienna mix. Change to the no. 1 brush and paint highlighted leaves using neat cadmium lemon. Repeat these steps across the painting.

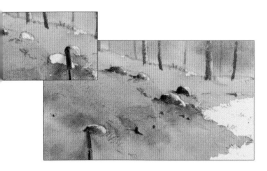

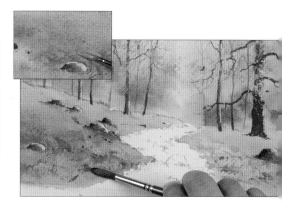

25 Remove the masking fluid from the stones and mix: ultramarine and rose madder for purple, and burnt sienna and ultramarine blue for shadow. Paint the purple on the stones first, using the no. 4 brush and leaving a white highlight, then drop in shadow and a little dash behind each stone for a cast shadow. Soften the colour into the ground with clean water.

26 Paint the foreground rocks in the same way but add some green mixed from aureolin and cobalt blue for moss. Paint aureolin and burnt sienna on to the ground to add warmth.

27 Use the no. 8 brush and cadmium lemon mixed with aureolin to paint leaves on the ground. Continue creating the ground texture with cadmium lemon and burnt sienna, then with burnt sienna and ultramarine blue.

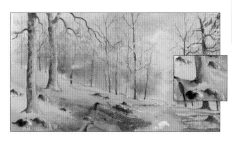
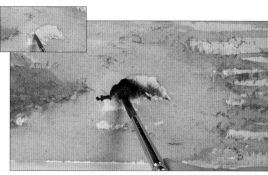

28 Wet the path with clean water, leaving the stone dry. Float in the purple mix of ultramarine blue and rose madder with the no. 8 brush.

29 Use the same mix to paint dappled shadow across the land on both sides of the path, from the trees and foliage. Soften the shadows with clean water. Use the no. 4 brush to paint a cast shadow to the left of each tree. Allow to dry.

30 Paint the rock in the path with a green mix of aureolin and a little cobalt blue, then drop in burnt sienna and ultramarine blue for the shadowed side.

31 Make any white marks into stones by painting their left-hand sides and undersides with the no. 4 brush and burnt sienna and ultramarine blue, suggesting shadows.

32 Make a thick mix of Naples yellow and burnt sienna and make dry brush marks to create leaves catching the light.

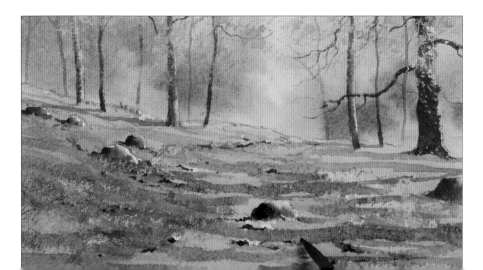

33 Use the shadow mix to add shadows across the path.

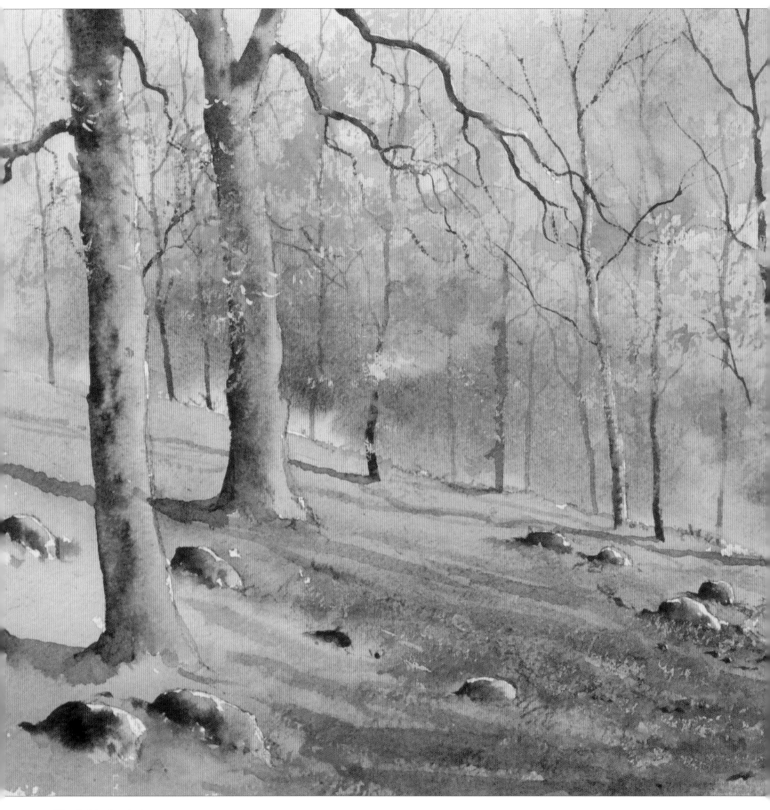

The finished painting.

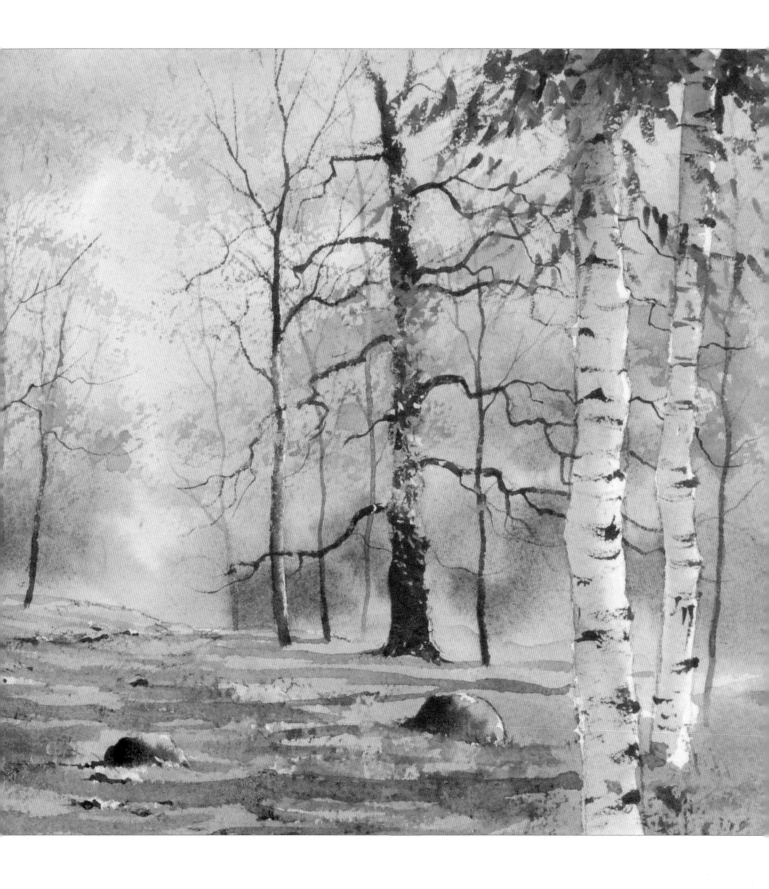

Oak Trees

On a summer walk in Norfolk I came across these beautiful old oaks, immediately recognising that they would make an excellent subject. I particularly liked the shape of the exposed roots and the way the positioning of the two main trees leads the eye to the gate and stile, which act as a natural exit point from the scene.

You will need

300gsm (140lb) Rough watercolour paper, 56 x 38cm (22 x 15in)

Masking fluid

Colours: cobalt blue, cobalt violet, cerulean blue, cadmium lemon, aureolin, viridian, ultramarine blue, burnt sienna, rose madder, raw sienna

Brushes: no. 16, no. 4, no. 8, no. 1 and no. 10 round

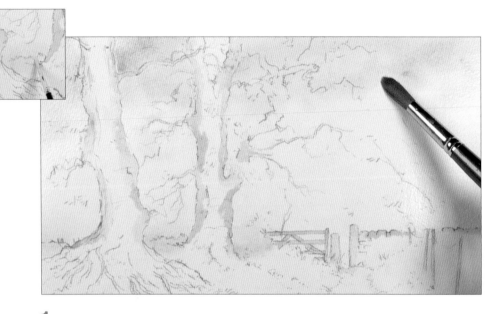

1 Transfer the scene on to watercolour paper. Use masking fluid on the tree trunks, fence and stile. For the grass around the trees, wet a large area of the painting first and then apply masking fluid so that it creates feathery shapes. Mix your colours, making each wash thicker than the one before: a thin wash of cobalt blue with a little cobalt violet; a thin wash of cerulean blue; cadmium lemon; aureolin and cobalt blue for a bright green; a dark green from viridian, ultramarine blue and burnt sienna; a cool grey-green from viridian and cobalt violet. Wet the background down to the masking fluid with clean water and using the no. 16 brush, float in cobalt blue and cobalt violet at the top of the sky.

Tip

When working wet in wet, as in the early stages of this painting, each subsequent wash should be thicker than the one before, to avoid 'cauliflowers' forming.

2 Painting wet in wet, drop cerulean blue lower down. The cooler colour in the lower sky creates the effect of distance.

3 Clean the brush and pick up cadmium lemon. Wait half a minute for the paper to dry a little so that the paint does not spread too fast, then touch in the yellow to suggest foliage. It will turn slightly green where it blends with the blue.

4 Dab in the bright green with the no. 4 brush.

5 Using the no. 8 brush and the grey-green mix, pick out darker areas near the ground. Drop in the dark green wet in wet.

6 Add more cobalt violet to the grey-green mix to create a cool pink-grey in places.

7 While the paint is still wet, use the no. 1 brush and cadmium lemon, which is opaque, to pick out highlights in the foliage. Paint on the bright green mix in the same way, then allow the painting to dry.

8 Remove the masking fluid from everywhere except the posts. Tidy any edges by painting the areas between the masked shapes using the dark green mix.

9 Mix the tree colours: a purple from cobalt blue and rose madder; a bright green from aureolin and cobalt blue; raw sienna and rose madder for warmth and a thick purple-brown from burnt sienna, ultramarine blue and rose madder. Using the no. 10 brush, wet the trunk with clean water. Paint on raw sienna and rose madder, then drop in the purple and blend it in.

10 Use the no. 8 brush to introduce a touch of bright green wet in wet.

11 Drop in purple-brown on the right-hand side and blend it so that the trunk looks rounded. Add vertical strokes to imply the texture of the bark using the point of the brush.

12 Add more purple-brown to the right-hand side and to define the roots. Paint raw sienna and rose madder on to the branch and then drop in the dark purple-brown wet in wet.

13 Use the no. 4 brush to paint in more branches, which do not need to be in the outline. Complete the very finest branchwork using the no. 1 brush and a thin mix of cobalt blue, burnt sienna and rose madder.

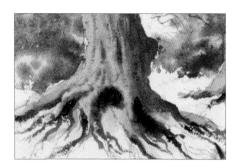

14 Repeat steps 9–13 to paint the right-hand tree. Using the no. 8 brush and the purple-brown mixed from burnt sienna, ultramarine blue and rose madder, paint branches, leaving gaps for foliage. Paint the deep hollow using the same colour.

15 The left-hand tree has dried lighter and looks weaker, so I have used the no. 1 brush and the purple-brown to add more lines to suggest the bark's texture.

16 Emphasise the darks in the roots with the same brush and paint mix. Use some dry brush work to suggest roots emerging from soil.

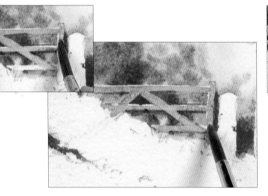
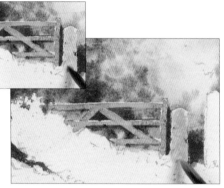
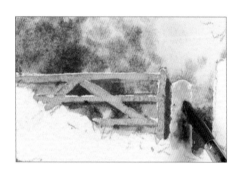

17 Use the no. 8 brush to paint raw sienna and rose madder on the gate, leaving a tiny white edge at the top for highlights. Drop a little cerulean blue into the first colour wet in wet to grey it.

18 Paint the gate post with raw sienna, leaving a little white at the top again. Drop in aureolin mixed with cobalt blue to suggest moss.

19 Still working wet in wet, float in a little purple mixed from cobalt blue and rose madder.

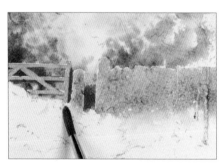

20 Repeat the same wet in wet sequence over the wall, painting with raw sienna, then green, then purple.

21 Warm the wall with a little more raw sienna, then soften the bottom of the gate post and wall with clean water so that the paint does not dry in a hard line and you can come back to it later.

22 Pick up neat cadmium lemon on the no. 8 brush and paint the foliage in front of the trees with the dry brush technique. The opaque colour will show up against the darker paint. In the same way, add a green mix of aureolin and cobalt blue.

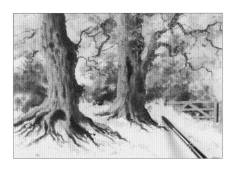

23 Change to the no. 1 brush and dab on tiny dashes of neat cadmium lemon against the trunk and branches. Do the same with the green mix against lighter areas.

24 Use a dark brown mix of burnt sienna and ultramarine blue and the no. 1 brush to paint more branchwork at the edges of the tree. Paint everything from the outline and add more if it seems right.

25 Mix the colours for the foreground: a thin wash of cadmium lemon; green from aureolin and cobalt blue; a cool green from viridian and cobalt violet; for the path, a purple from cobalt blue and rose madder and an orange from raw sienna and rose madder. Use the no. 8 brush to wash cadmium lemon over the area where the bright grass meets the foliage.

26 Introduce the bright green around the base of the trees, wet in wet. Drop in the cool green.

27 Add raw sienna and rose madder below the grass. Float in the purple mix and add water to soften it.

28 Add more bright green wet in wet and allow the colours to merge.

29 Float in more cadmium lemon around the tree roots, then add more purple.

30 Take the no. 16 brush and paint raw sienna and rose madder in the foreground, wet in wet. Add a little purple as shown.

31 Paint with clear water at the far end of the path to create a bright spot. Then paint with purple over the path. The brush strokes should be used to create the effect of a dip in the path. Blend in raw sienna and rose madder, then soften the edge on the right-hand side with clean water.

32 Drop in bright green mixed from aureolin and cobalt blue on the left, and add the viridian and cobalt violet mix in the foreground.

33 Work on the right-hand side of the foreground in the same way. Wet the area below the wall, then drop in cadmium lemon. Change to the no. 10 brush and float in bright green wet in wet.

34 At the bottom of the painting, add purple and then raw sienna with rose madder.

35 Using the no. 8 brush, paint the cool green from viridian and cobalt violet on the bottom of the foreground, then use the tip of the no. 4 brush to paint a bush in front of the wall.

36 Beyond the wall, paint with a purple mixed from cobalt blue and rose madder to highlight the wall itself. Leave a thin line of white at the top of the wall to indicate light catching the tops of the stones.

37 Mix a dark green from viridian, ultramarine blue and burnt sienna and drop this in wet in wet behind the wall, to create a dark against light contrast.

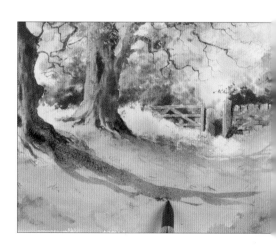

38 Use the no. 4 brush and raw sienna with rose madder to pick out some stones at random. Allow the paint to dry. Change to the no. 1 brush and use burnt sienna and ultramarine blue to paint crevices between the stones.

39 Make a thin mix of cobalt blue and rose madder for shadows and paint dappled shadows on the gate using the no. 8 brush. Add a shadow on the right-hand side of the gate post, and dappled shadows on the wall.

40 Paint dappled shadows from the foliage across the path, following the dip of the path. Use the no. 16 brush to paint the shadow from the foreground tree.

41 Soften parts of the tree shadow with the no. 8 brush and clean water, then add more dapples wet in wet.

42 Use the no. 16 brush to paint shadow in the bottom left-hand corner to bring it forwards, and soften it in with clean water.

43 Pick up raw sienna and rose madder on the no. 4 brush and begin to develop the roots of the foreground tree.

44 Paint shadow under the roots using a dark brown mix of burnt sienna and ultramarine blue.

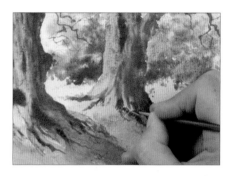

45 Repeat steps 43 and 44 on the other tree. Then use thick cadmium lemon on the no. 1 brush to paint grass round the base of the second tree.

46 Turn some of the light parts of the foreground into stones by darkening the undersides with the no. 1 brush and the dark brown mix.

47 Use the shadow mix to paint perspective lines in the path to lead the eye into the scene.

48 Rub the masking fluid off the posts. Using the no. 1 brush and a dry mix of dark brown, drag the brush down the right-hand side of the posts to create the effect of weathered wood.

Overleaf

The finished painting.

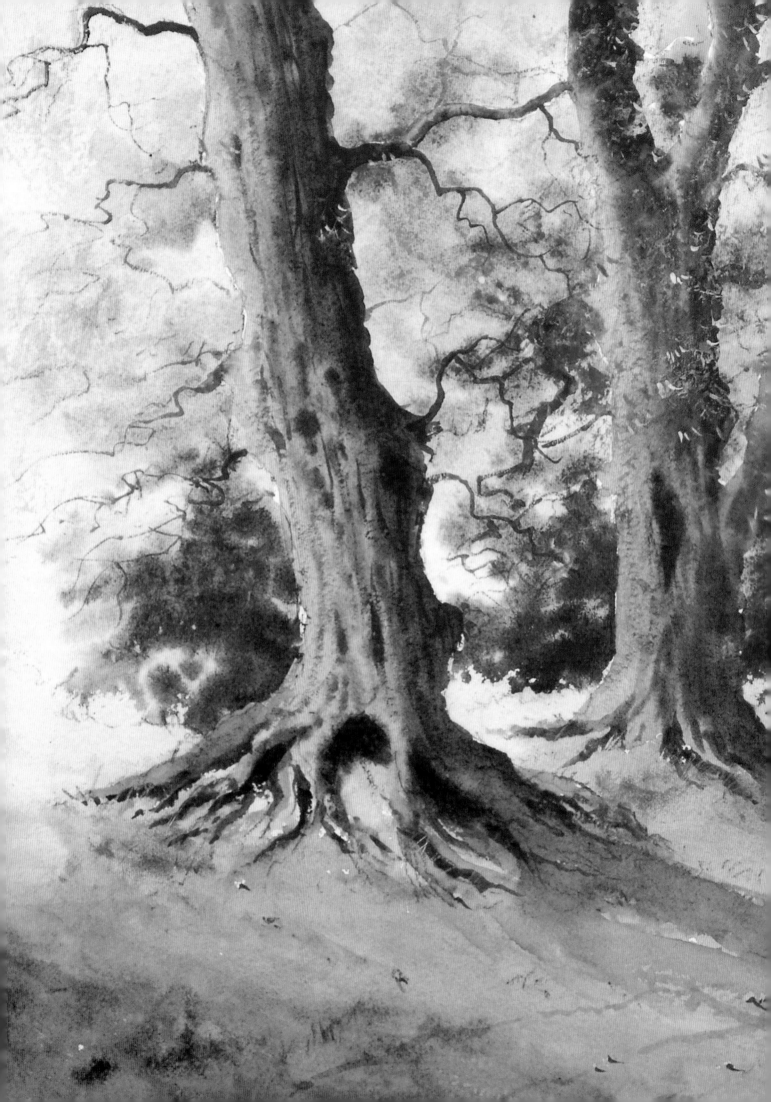

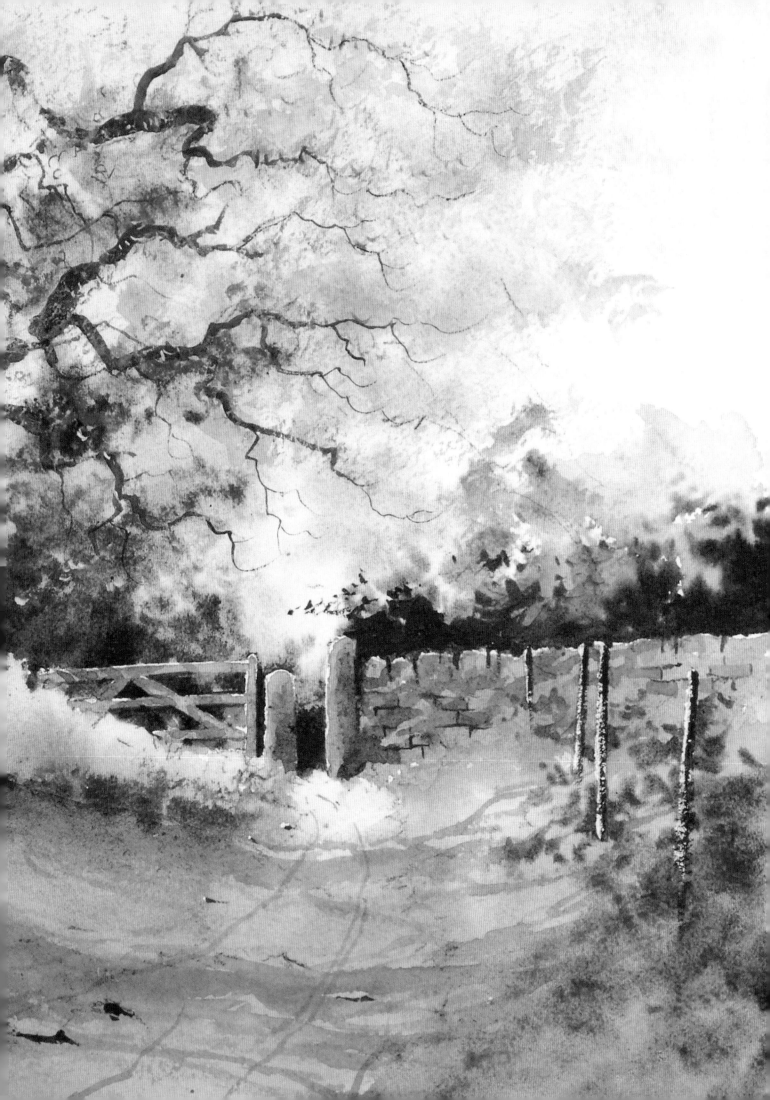

Old Willow and Boat

I came across this subject during a summer trip on a small, electric, flat-bottomed boat that accessed some very narrow parts of the Norfolk Broads, away from the crowds. I admit I had to move the wind pump to achieve the right composition (it was actually some distance downstream). That's the advantage of being an artist!

TRACING
12

You will need

300gsm (140lb) Rough watercolour paper, 56 x 38cm (22 x 15in)

Masking fluid

Kitchen paper

Colours: quinacridone gold, cobalt blue, cobalt violet, aureolin, raw sienna, burnt sienna, viridian, ultramarine blue, rose madder, cadmium lemon, white gouache

Brushes: large wash brush; no. 16, no. 8, no. 1, no. 4 and no. 10 round; no. 2 rigger and 13mm (½in) flat

1 Transfer the image on to watercolour paper. Apply masking fluid on the edges of the tree trunk, where the land meets the water and on the top of the boat. Prepare a very thin wash of quinacridone gold and a thin wash of cobalt blue and cobalt violet. Paint the gold wash all over the painting with a large wash brush.

2 Use the no. 16 brush to paint the purple mix at the top of the painting for a hint of sky. Allow to dry.

Tip

Quinacridone gold is a very strong colour so should be used sparingly.

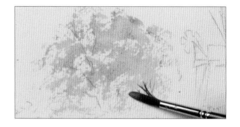

3 Mix cobalt blue and cobalt violet; a green from aureolin and cobalt blue; raw sienna and burnt sienna; viridian and cobalt violet. Use the side of the no. 8 brush and the cobalt blue and cobalt violet mix with the dry brush technique to indicate the distant tree. Introduce the light green wet in wet.

4 Apply the raw sienna and burnt sienna mix, then the grey-green mixed from viridian and cobalt violet lower down.

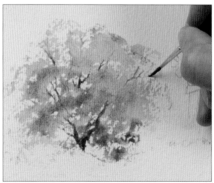

5 Add burnt sienna to darken the grey-green and use the no. 1 brush to paint bits of the branches showing through the foliage.

6 Paint the windmill with grey mixed from cobalt blue, cobalt violet and burnt sienna and soften the bottom edge. Paint the top with raw sienna and burnt sienna, then drop in grey wet in wet.

7 Use the no. 4 brush and the grey to suggest details loosely. Paint the small sails with raw sienna and burnt sienna, then drop in the grey wet in wet. Allow to dry.

8 Use the no. 1 brush to paint the sails with raw sienna and burnt sienna, then drop in grey. Use the grey to add detail. Allow the windmill to dry, then run a clean, damp brush over it and fade it back by dabbing it with kitchen paper.

9 Mix cobalt blue and cobalt violet; raw sienna and burnt sienna; viridian and cobalt violet; green from quinacridone gold and cobalt blue; dark green from viridian, ultramarine blue and burnt sienna; and bright green from aureolin and cobalt blue. With the no. 16 brush and clean water, wet the middle distance, above the masking fluid line and up to the windmill.

10 Use the no. 8 brush to drop in cobalt blue and cobalt violet, then the bright green, then raw sienna and burnt sienna, working quickly wet in wet.

11 Change to the no. 10 brush and paint to the water's edge with the green mixed from quinacridone gold and cobalt blue. Then with the no. 8 brush, drop in viridian and cobalt violet.

12 Drop in the dark green under the willow tree and along the water's edge, to create a dark contrast to the boat.

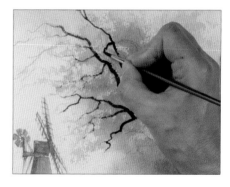

13 Wet the area behind the tree and repeat steps 10 to 12, dropping in cobalt blue and cobalt violet first, then the other colours in succession wet in wet. Allow to dry.

14 Use the no. 8 brush and dry brush work to begin painting the willow's foliage with cobalt blue and cobalt violet. Add a cool grey from viridian and cobalt violet. Soften some marks with clean water and allow them to dry.

15 Take the no. 4 brush and a dark brown mixed from burnt sienna and ultramarine blue and paint the branches of the willow. Dry brush work makes the branches look more authentic. Allow to dry.

 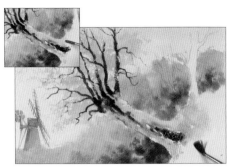

16 Mix cobalt blue and cobalt violet; raw sienna and rose madder and a green from aureolin and cobalt blue. Remove the masking fluid from the tree trunk. Rewet the ends of the branches and float in cobalt blue and cobalt violet, then raw sienna and rose madder.

17 Add more of the dark brown so that it softens into the lighter colours. Paint streaks for bark texture and a dark hollow.

18 Paint raw sienna and rose madder in the bend between trunks, then drop in the cobalt blue and cobalt violet mix, then a hint of the green mix.

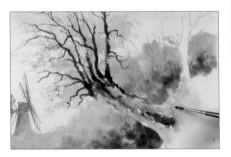 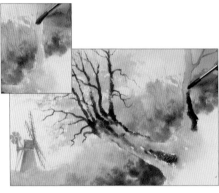 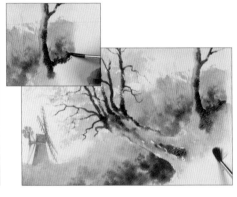

19 Paint detail at the top edge of the trunk with the dark brown, then add raw sienna and rose madder in the bend.

20 Paint the purple mix up the second trunk, then drop in raw sienna and rose madder. Shade the right-hand side with the dark brown.

21 Do a little dry brush work along the top edge of the ground to the right of the tree with the dark brown. Then blend in quinacridone gold and cobalt blue. Soften the bottom edge with clean water so that you can work on it later without a hard edge.

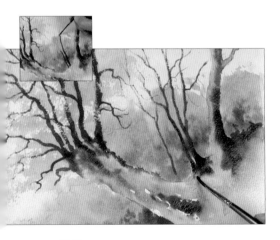 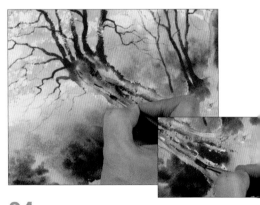

22 Use the no. 4 brush and the dark brown to paint the branches growing from the bend. Add more of the purple mix to the bend and then bring the brown down so that it blends in as shown.

23 Change to the no. 1 brush and follow the branches outwards to paint fine twigwork with the dark brown mix.

24 Use the no. 4 brush and the brown mix to build up the texture of the bark. Use the side of the brush and the dry brush technique and soften the marks with clean water in parts. Fill any white gaps with raw sienna and rose madder.

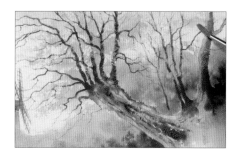

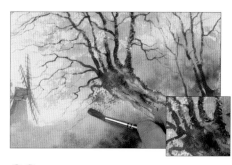

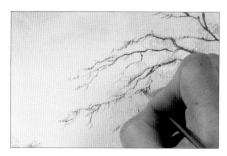

25 Make foliage colours: cadmium lemon; viridian and cobalt violet; and green from aureolin and cobalt blue. Use the no. 8 brush and the dry brush technique with neat cadmium lemon in front of the dark branches. Do the same with the green mix in front of the sky.

26 Continue the dry brush technique with the viridian and cobalt violet mix. Use the no. 1 brush and neat cadmium lemon to add dashes for leaves in front of dark branches.

27 Add more dashes for leaves with the green and the viridian and cobalt violet mix.

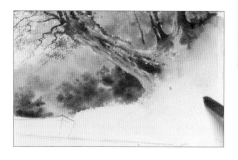

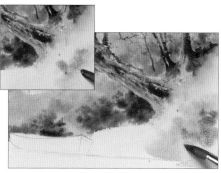

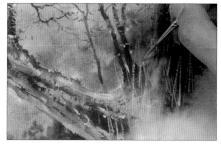

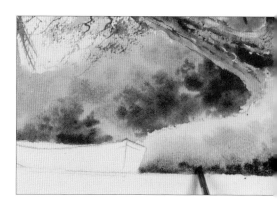

28 Mix colours for the bank area: a thin wash of quinacridone gold with a little cadmium lemon for a bright grass mix; quinacridone gold and cobalt blue for green; a cool green from viridian and cobalt violet and a dark green from viridian, ultramarine blue and burnt sienna. Wet the area on the right.

29 Drop in the bright grass mix first, then the green, then the cool green, working wet in wet.

30 Repeat the same sequence of colours in the area up to the hull of the boat. Finally add the dark green along the waterline.

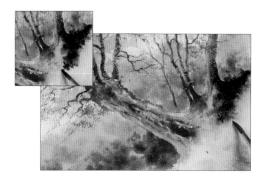

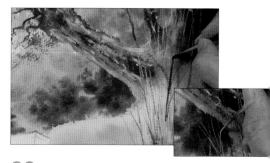

31 Re-wet the dark brown area of ground to the right of the willow and paint burnt sienna and ultramarine down into the wet area. Blend the edges with quinacridone gold and cobalt blue. Allow to dry.

32 Mix colours for grass: aureolin and cobalt blue for green; viridian, ultramarine blue and burnt sienna for dark green; white gouache with viridian and cobalt blue for a chalky green. Use the no. 2 rigger with neat cadmium lemon to flick up grasses against the dark area. Repeat with the chalky green.

33 Use the green mixed from aureolin and cobalt blue to flick up grasses and reeds against the bright bank, then do the same with the dark green. Extend the grasses into the dark area in the background using the cadmium lemon and chalky green mixes.

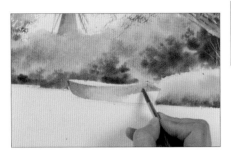
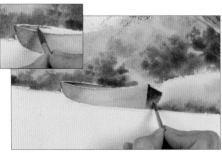
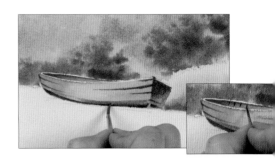

34 Remove the masking fluid from the top of the boat. Mix raw sienna and burnt sienna and use the no. 8 brush to paint along the boat's side. Add water to create a bright spot in the middle, and use a stronger mix towards the front.

35 Use the same colour on the inside of the boat, leaving a white line for highlights. Then change to the no. 4 brush and a dark brown mix of burnt sienna and ultramarine blue to paint the shadow inside the boat, and the bow facing away from the light. Wash in the lighter colour lower down.

36 Use the same brush and the dark mix for the clinkered side of the boat and the dark underside. Soften the edge of the underside with the lighter mix. Add details inside the boat with the no. 1 brush. Allow to dry.

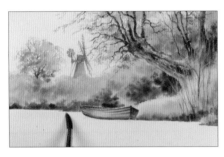

37 Remove the masking fluid from the water. The water should reflect all the colours above, so mix quinacridone gold and cadmium lemon; cobalt blue and cobalt violet; raw sienna and burnt sienna; a bright green from aureolin and cobalt blue; a dark brown from burnt sienna and ultramarine blue; a cool green from viridian and cobalt violet and a dark green from viridian, ultramarine blue and burnt sienna. Wet the water area with clean water and the no. 16 brush. Leave a dry line at the top and be careful not to smudge the boat.

38 Float in the cobalt blue and cobalt violet mix at the bottom of the water, reflecting the colour at the top of the sky. Next float in raw sienna and burnt sienna at the top of the water, reflecting the foliage colours above.

39 Drop in the bright green, then the cool green, wet in wet. Paint raw sienna and burnt sienna for the reflection under the boat.

Tip

Try to work rapidly on the water area so that the paint does not dry before you drag the colour down to create vertical reflections.

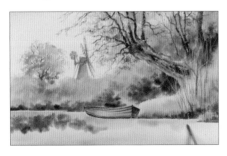

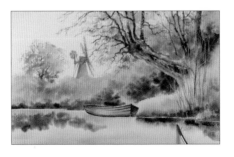
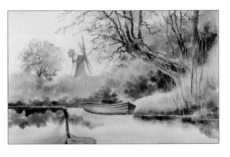

40 On the other side, drop in the quinacridone gold and cadmium lemon mix, then the bright green.

41 Drop in the dark green at the top and then the cool green lower down, still working wet in wet.

42 Paint the dark green along the water's edge on the left, leaving a white line at the top.

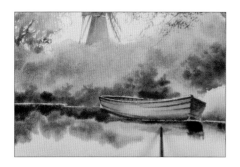

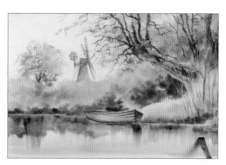

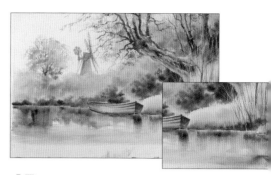

43 Paint the reflection under the dark bow of the boat with the dark brown mix, then soften this with water to paint the rest of the reflection.

44 While the painting is still wet, use the 13mm (½in) flat brush to drag the wet paint down vertically, creating the effect of reflections in still water.

45 Use the flat brush to paint cobalt blue and cobalt violet ripples horizontally across the foreground. Add bright green on the right.

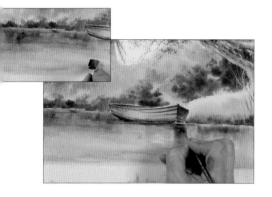

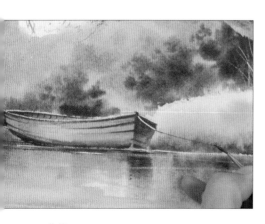

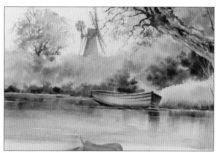

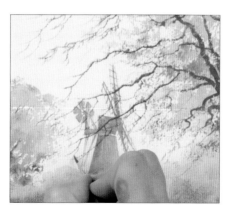

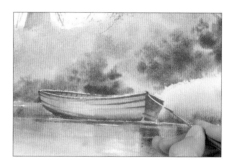

46 Use horizontal strokes of the flat brush and clean water to soften the vertical reflections on the left. Allow to dry. Use the no. 1 brush to paint dark brown ripples under the boat.

47 Use the no. 1 brush with neat white gouache to paint tiny horizontal ripples.

48 Use the same brush and white gouache to paint the rope where it crosses the dark side of the boat.

49 Wash the brush and carry on the rope where it passes over the bright grass using dark brown. In this way the rope is both light against dark and dark against light.

50 On standing back to view the painting, I decided to extend the willow branches so that the finer ends cross the windmill. Do this with the no. 1 brush and a thinned dark brown mix.

51 Add more leaves using the bright green mix of aureolin and cobalt blue.

Overleaf

The finished painting.

81

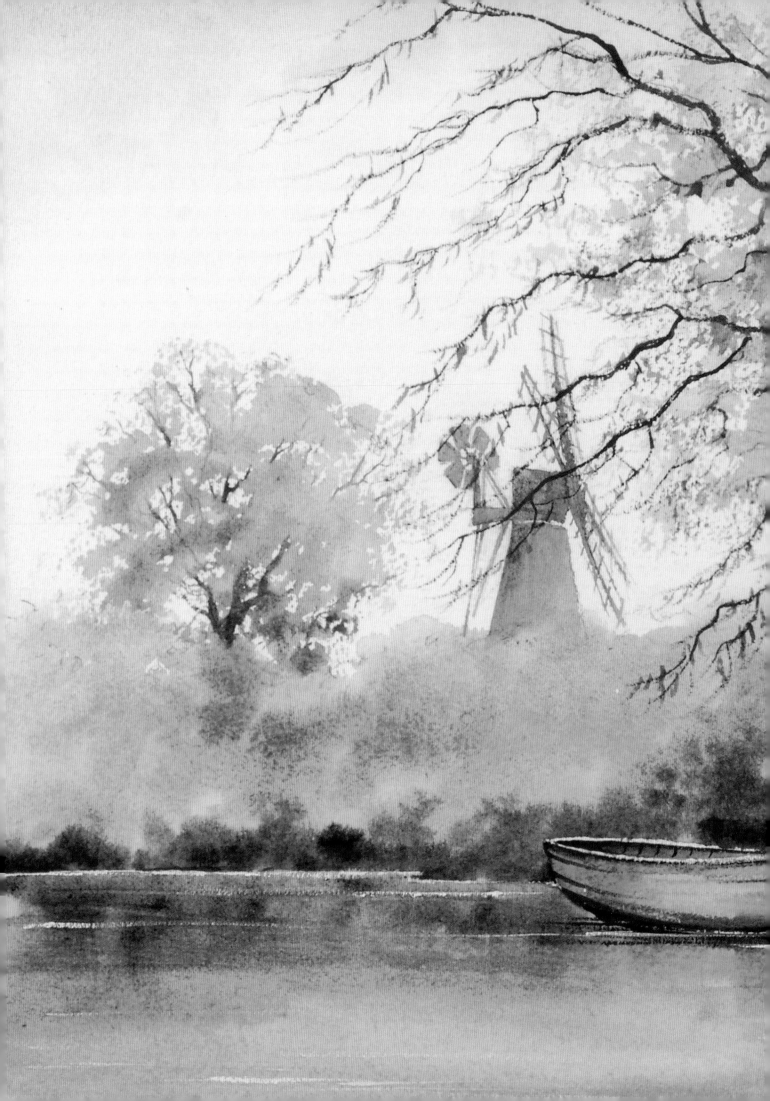

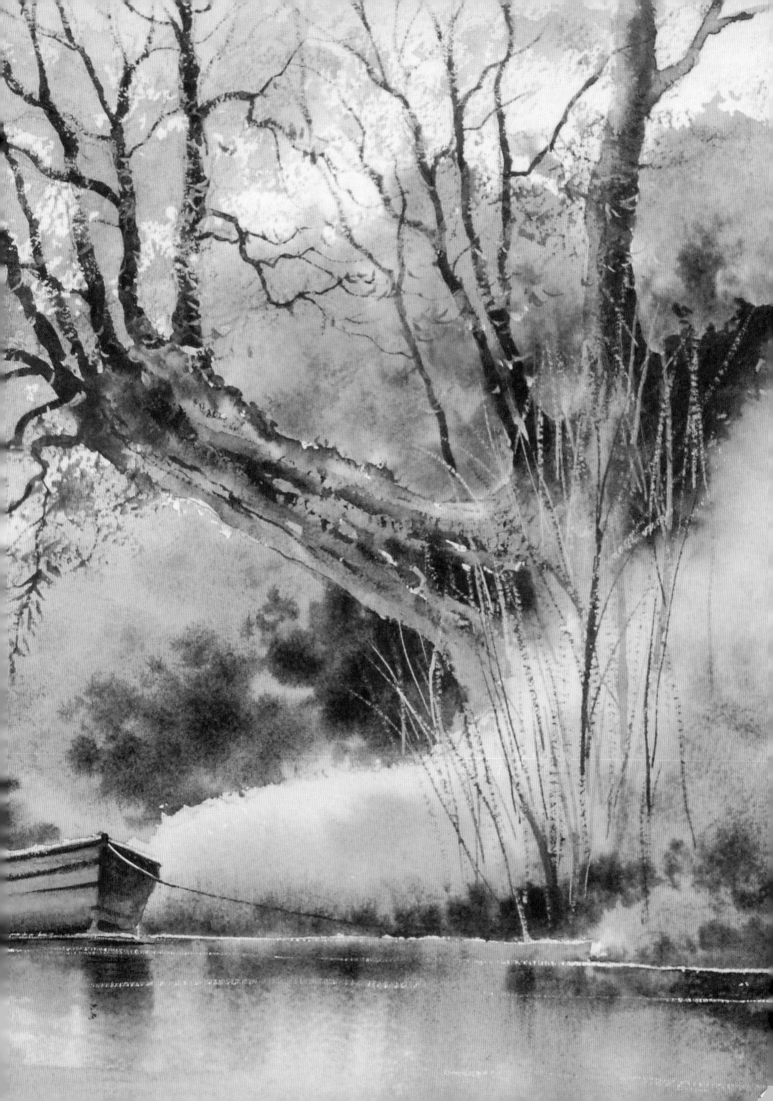

Autumn at Cromford Canal

45.7 x 30.5cm (18 x 12in)

I have lost count of the number of times I have painted in this location, but I never tire of it. I tried to create the feeling here that you are glimpsing the wharf sheds and canal boats through a curtain of autumn foliage. I particularly liked the way the bright coloured tarpaulins on the boats provided a man-made colour to contrast with the natural greens, browns and yellows. This is an important counter-change, which draws the viewer into the scene.

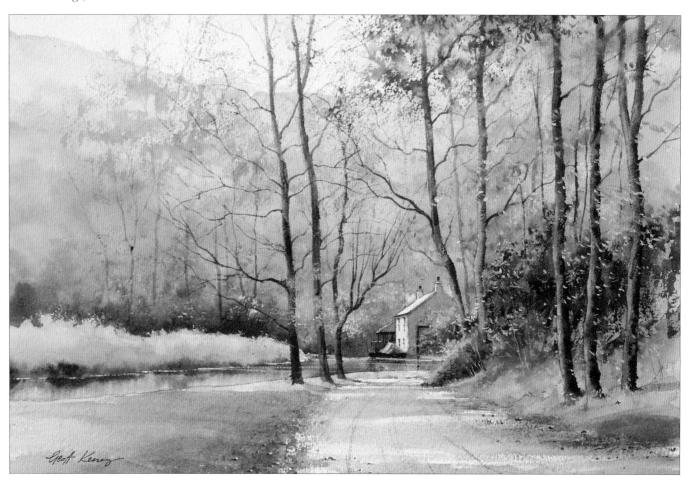

Grand Union Canal, Islington

36.5 x 26cm (14 ³/₈ x 10¼in)

Not strictly a painting about trees and woodlands, but the loose treatment of all the masses of summer foliage is essential to the mood of the scene.

I enjoy from time to time painting a scene looking into the light or 'contre jour'. Note how in this scene the bright light highlights the shapes of the people returning from their day at work. Note also the rich, warm foreground shadows.

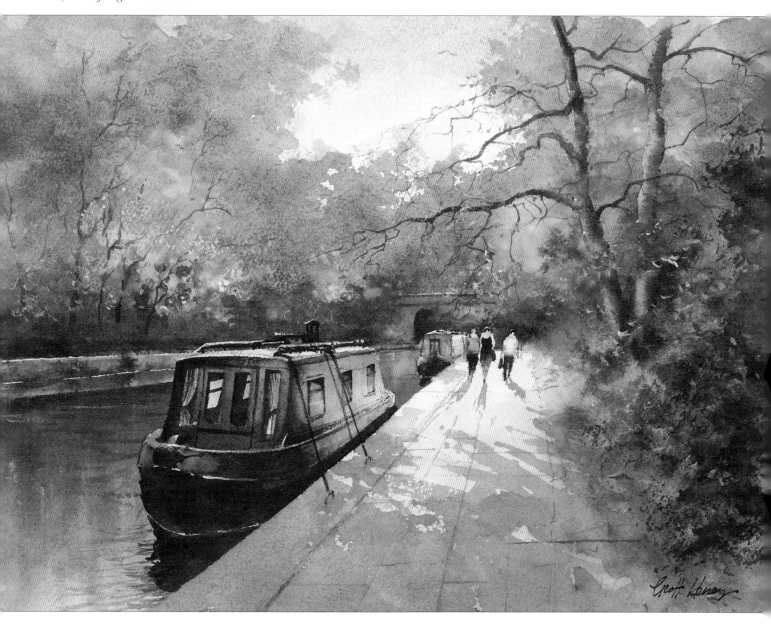

HILLS &
MOUNTAINS

by Arnold Lowrey

I took up art as a hobby thirty-five years ago to act as a foil to my career in engineering. Little did I realise that I had embarked on one of the four great enquiries of life – the other three being science, philosophy and theology. I started attending a local evening class thinking it would be a restful occupation. That was another shock, as painting requires an intense concentration which can be very tiring. However, the stress caused is good stress because it cancels out the bad stresses we have in our daily lives. Remember, the reason we want to paint is not that it is restful but because it is very, very interesting. Unlike a jigsaw puzzle where the more you complete the less there is to do, with painting the more you do, the more you realise there is to learn!

Painting mountains and hills can be exciting and rewarding if approached in the right way. The biggest mistake made by beginners is not to consider the quality of the silhouettes and shapes that make up the picture. Most great paintings are not exact copies of what they represent; more often than not the artists have altered what they see to make them more interesting and attractive to the eye. Remember, good shapes make great paintings.

Your journey into painting will encompass two main disciplines – art and craft. The craft side is, for example, learning about paint handling, colour mixing, how to paint skies and seas, etc.; the art is about how you interpret your feelings for the subject. The five paintings in this section help you practise your craft and, if you wish, a little of the art to help you 'sing with your own voice'.

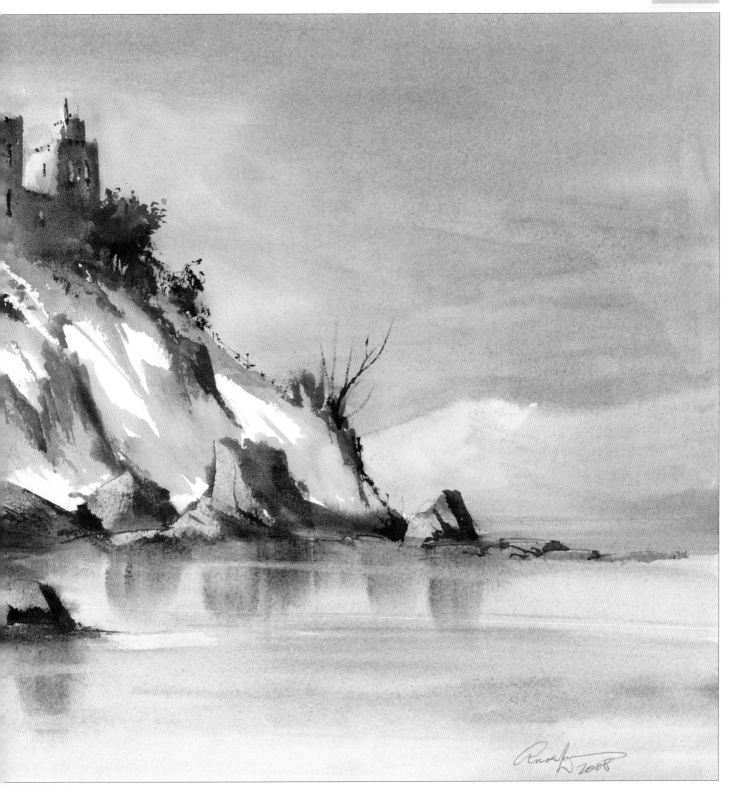

Castle

42 x 29.5cm (16½ x 11½in)

This hillside, with its castle and trees, forms an interesting shape with many textures. The surrounding sky and water are soft to balance it. Some warm colours were placed in the hillside and castle to draw the eye. In general, paintings that include some warm colours are far more appealing than those that do not. The tracing for this painting is available at the front of the book (tracing 1).

Distant Hills

In this painting I have tried to portray a huge expanse of land with hills in the distance. By placing the house in the foreground I have accentuated the scale of the landscape. The sunlight is coming from the left so I have painted the shadows accordingly, putting some dark trees against the house to make it appear more sunlit.

You will need

180gsm (90lb) NOT watercolour paper

Small piece of sponge

Kitchen paper

Kneadable (putty) eraser

Safety razor blade

Paints: cobalt blue, French ultramarine, cadmium scarlet, cadmium lemon, new gamboge, Winsor blue (green shade), burnt umber, burnt sienna, permanent rose, titanium white

Brushes: 25mm (1in) flat brush, 13mm (½in) flat brush with a scraper end, no. 3 rigger

1 Beginning with the sky, dampen the area using a damp sponge. Avoid over-wetting the paper.

2 Moving on quickly, before the background has time to dry, use the 25mm (1in) flat brush to lay on a wash of cobalt blue. Add some French ultramarine over the top to deepen the colour towards the top of the sky.

3 Dab out the clouds using a screwed-up piece of kitchen paper. Avoid producing hard edges.

Tip

Always clean the flat mixing area of your palette with a damp kitchen sponge and wash out your brush before mixing another colour.

4 For the distant hills, mix some French ultramarine with a touch of cadmium scarlet to create a blue mid-tone and lay in the colour over the peak of the hill, blending it out to a paler tone towards its base.

5 Use the kitchen paper to lift out a small cloud near the top of the hill.

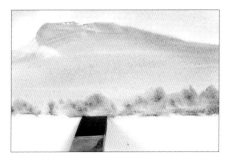

6 Complete the hill using the same colour.

7 Using a stronger version of the same mix, put in the forest at the foot of the hill on the right. Use the side of the brush to paint in the shape of the forest rather than the individual trees.

8 Use the flat edge of the brush to even up the bottom of the trees.

9 Make a mix of cadmium lemon and a hint of cobalt blue, and lay an even wash across the mid-ground.

10 Further down the painting, add in some new gamboge to warm up the mix. The transition from cool to warm colours will help bring the picture forwards.

11 Use a damp, clean brush to soften the edge of the paint.

12 Paint the roof of the house using new gamboge applied with the flat edge of the brush.

13 Wring out the brush and pick up some cadmium scarlet. Add a little of the colour to the roof, allowing it to blend with the new gamboge.

Tip

To control the amount of water in your brush (and to make sure there is not too much), mix your paint to the right colour with some water on the palette, clean and wring out your brush and then pick up the paint using a single stroke.

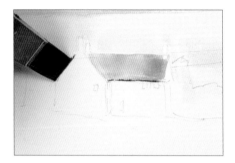

14 Using French ultramarine mixed with a little cadmium scarlet and very little water, dab on the gutters using the flat edge of the brush.

15 For the windows and doors, use the corner of the brush.

16 While the paint is drying, add the trees surrounding the house. Make a dark green using Winsor blue (green shade) and burnt umber and pick up with a single stroke. Dab on the paint using the side of the brush.

17 Add some warmth to the trees by adding some burnt sienna.

Tip

Dabbing paint on using the side of the brush results in a varied, 'sparkly' finish rather than a flat area of colour.

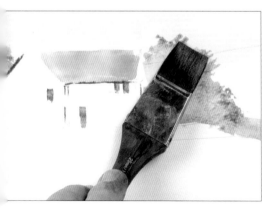

18 Paint the trees on the right-hand side of the house in the same way.

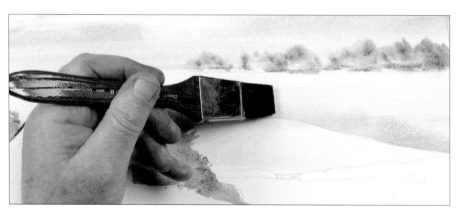

19 Mix some cobalt blue into a little of the green you have just used, and lay a green wash over the mid-ground behind the house. Lose the top edge by blending it in with a clean, damp brush.

90

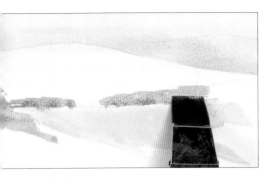

20 Paint in the yellow field just to the right of the house using a wash of new gamboge. Put in the hedgerow at the back of the field using a little new gamboge mixed with French ultramarine.

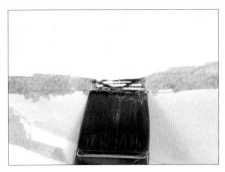

21 Add some more French ultramarine and some burnt umber to the mix, and draw in the gate using the flat edge of the brush.

22 Place some darker tones along the base of the hedge.

Tip

Dabbing on a line using the flat edge of the brush creates a more interesting line than one that is simply drawn on.

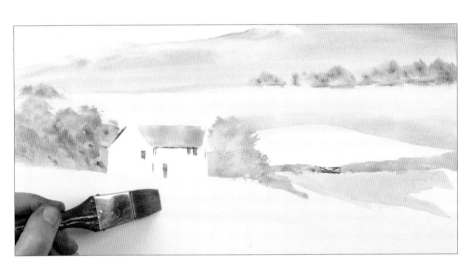

23 Lay a wash of cadmium lemon over the foreground field. Start at the edge of the field nearest the house, and gradually bring the colour forwards.

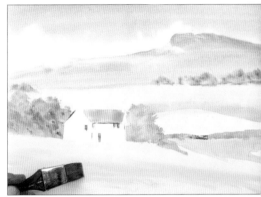

24 As you approach the foreground, introduce some new gamboge into the mix to warm it up.

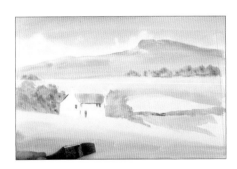

25 Finally, at the front of the picture, introduce some burnt sienna. This creates a gradual transition from cool to warm as you approach the foreground.

26 Make another dark green mix of Winsor blue (green shade) and burnt umber, and paint in the trees on the far right. Use the side of the brush, as in step 16.

27 Make a mix for the shadows (see the tip box opposite). Paint these on the front and sides of the house, and on the ground just in front of it (the light is coming from the left).

Tip

Shadows in these demonstrations are grey-blue. To produce this colour add to some cobalt blue a tinge of permanent rose (to slightly purple it) and then a tinge of cadmium scarlet (to grey it).

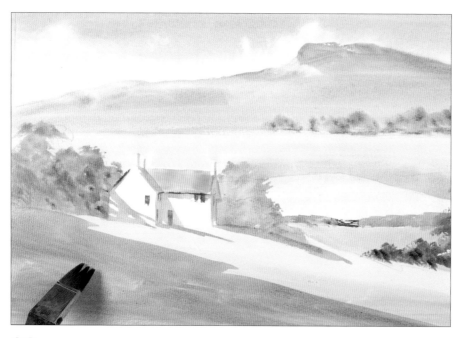

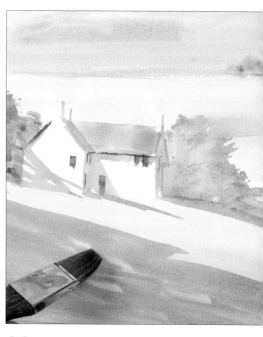

28 Use the same mix to put in the shadows cast by the trees, lying diagonally across the field.

29 Use a clean, damp brush to lift out the dapples of light falling on the ground while the paint is still wet.

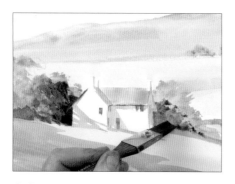

30 To lighten the house, make the trees on either side darker by applying a mix of burnt umber, burnt sienna and Winsor blue (green shade).

31 While the paint is still wet, use the scraper end of the 13mm (½in) flat brush to scrape out the shapes of some tree trunks and branches on the left.

32 Using the shadow mix, place more shadow on the right-facing slopes of the hillside.

33 Also place some shadows on the top of the hill, on the left. Soften them in with a clean, damp brush.

34 Using neat new gamboge, dab in the yellow foliage on the left-hand trees (by now, the paint underneath should be dry).

35 Paint in the fence posts either side of the house using titanium white and a no. 3 rigger. Place the posts irregularly and at different angles for a more realistic effect.

36 Using the 13mm (½in) flat brush, add a little burnt sienna to the dark green mix used in steps 16 and 26, and put in a hedgerow in the mid-ground. Soften the hard edges with a clean, damp brush.

37 Using the same dark green mix, draw in the fir tree to the right of the house.

38 Warm up the colour with a little burnt sienna, and paint in the rest of the tree.

40 When the painting is completely dry, remove any visible lines using a putty eraser.

39 Returning to the 25mm (1in) flat brush, strengthen the small field in the middle of the picture by placing a shadow across it.

Overleaf

The finished painting.

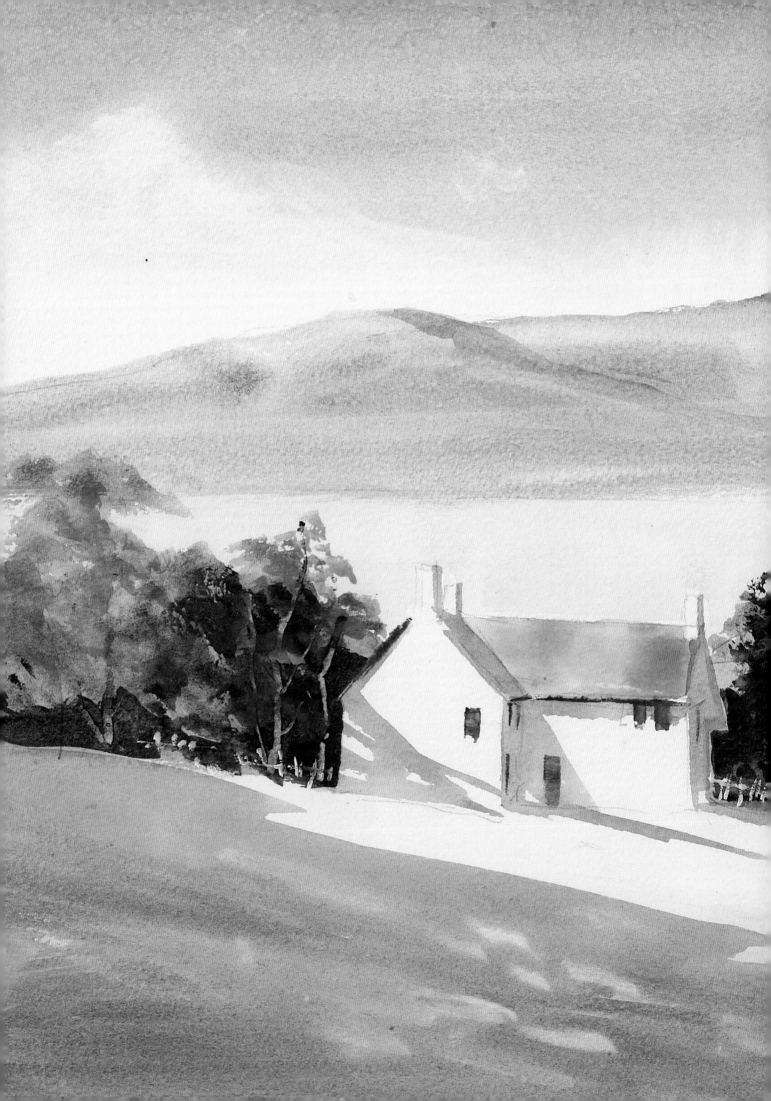

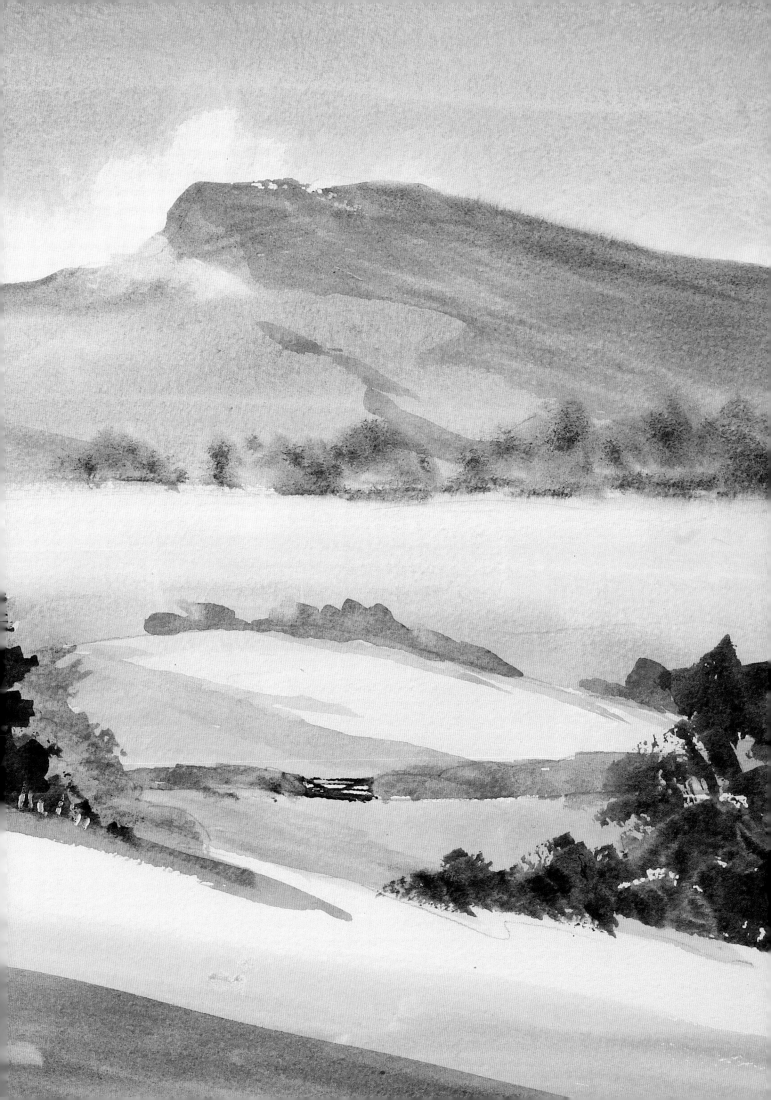

Alpine Scene

The main elements of this painting are the snow, sky, rocks, trees and shadows. Only the last four are painted – the sunlit snow is unpainted paper. It is important to paint the sky area dark enough so that the white snow contrasts against it. Treat each area of trees as a silhouette and don't attempt to paint every tree! Your aim is to achieve the impression of a forest, rather than a realistic picture of one.

You will need

180gsm (90lb) NOT watercolour paper

Small piece of sponge

Safety razor blade

Kneadable (putty) eraser

Paints: Winsor blue (green shade), cadmium scarlet, burnt sienna, French ultramarine, cobalt blue, permanent rose, burnt umber, new gamboge

Brushes: 25mm (1in) flat brush, 13mm (½in) flat brush with a scraper end, no. 3 rigger

1 Begin, as in the previous project, by dampening the sky area using a damp sponge.

2 While the background is still wet, make a watery mix of Winsor blue (green shade) and a little cadmium scarlet, and brush on the colour using the 25mm (1in) flat brush. Apply the brushstrokes in different directions to eliminate any streaks.

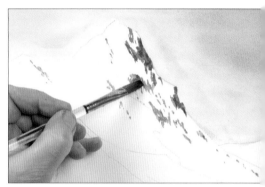

3 Make a grey-blue mix of burnt sienna and French ultramarine, change to the smaller flat brush and put in some of the rocks at the top of the mountain. Apply the paint using the corner of the brush. Add a little more burnt sienna to the mix to vary the colour.

Tip

Shadows in these demonstrations are grey-blue. To produce this colour add to some cobalt blue a tinge of permanent rose (to slightly purple it) and then a tinge of cadmium scarlet (to grey it).

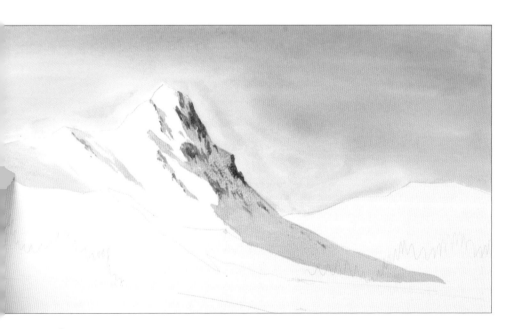

4 When the rocks are dry, make the shadow mix (see right) and use the larger flat brush to put in the shadows on the right-facing slopes of the mountain (the light is coming from the left).

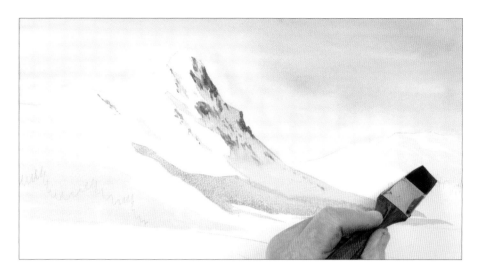

5 Continue laying in the remaining shadows, varying the colour and strength of the mix to create different depths of shadow.

6 Put in the forest at the foot of the mountain on the right-hand side using a blue-green wash of Winsor blue (green shade) mixed with burnt umber. To create the treetops, lay the brush flat against the paper and wiggle it up and down.

7 Strengthen the mix and place another layer of trees on top of the first. This will push back the first layer and give the forest depth.

8 Use the edge of the brush to dab in the foliage on the left-hand edge of the forest. Soften the edges with a clean, damp brush.

9 Add a little burnt sienna to the mix to warm it up and put in the trees on the left. The warmer colours will bring them forward and push the right-hand trees further back, giving depth to the picture. Use the flat edge of the brush to dab in the tree trunks and to suggest one or two individual trees.

10 Make a little more of the shadow mix (see page 96) and pull down the shadows from the trees.

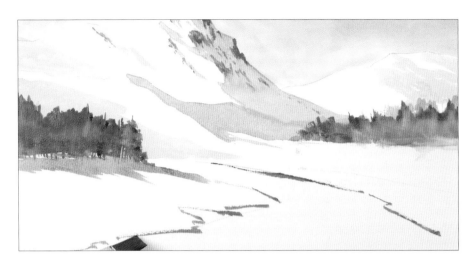

12 Mix some new gamboge and burnt sienna and put in the foreground rocks on the left.

11 Make a dark grey mix of French ultramarine and burnt sienna and drag an uneven line down from the corner of the shadow into the foreground. Drag another line from the foot of the mountain. These lines help break up the foreground and lead the eye into the picture.

Tip

When using a razor blade to scrape out highlights, make sure the paint is still wet and place the razor blade with the edge flat on the surface. Tilt the blade in the direction you wish to scrape and push the pigment firmly in that direction. Be careful you don't cut yourself – use safety blades, which have a blade on only one side.

13 While the paint is still wet, use a razor blade to scrape away the paint on the left-hand sides of the rocks where the sunlight hits them. The razor blade produces hard edges, mimicking the sharp corners of the rock.

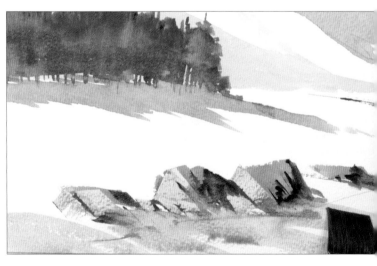

14 Make a mix of burnt sienna and French ultramarine and darken the shadows on the right-hand sides of the rocks.

15 Using the shadow mix (see steps 4 and 10), put in the shadows around the rocks on the snow.

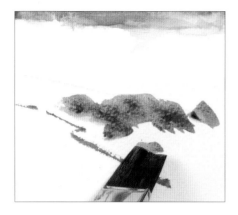

16 Use the same mix as before to put in the rocks on the right.

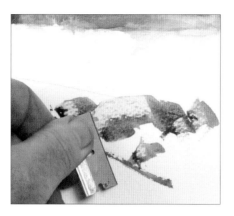

17 Scrape away the paint to create highlights using the razor blade.

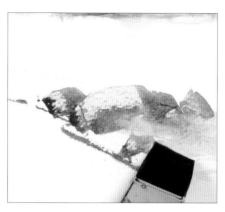

18 Put in the shadows below the rocks.

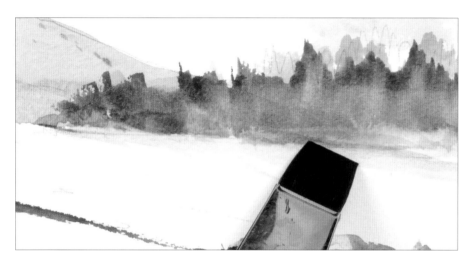

19 Also place the shadows beneath the trees on the right.

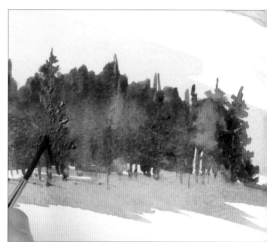

20 Using the no. 3 rigger, add some details to one or two of the foreground trees on the left of the picture. This adds texture and brings the trees further forward. Use a strong mix of burnt sienna and Winsor blue (green shade).

21 Make a small quantity of Winsor blue (green shade) mixed with burnt umber and dot in some distant trees at the top of the slope on the left.

22 When the painting is completely dry, remove any visible lines using a putty eraser.

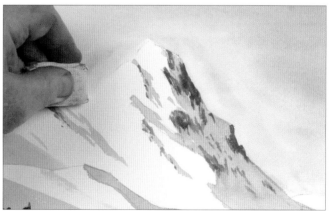

Overleaf

The finished painting.

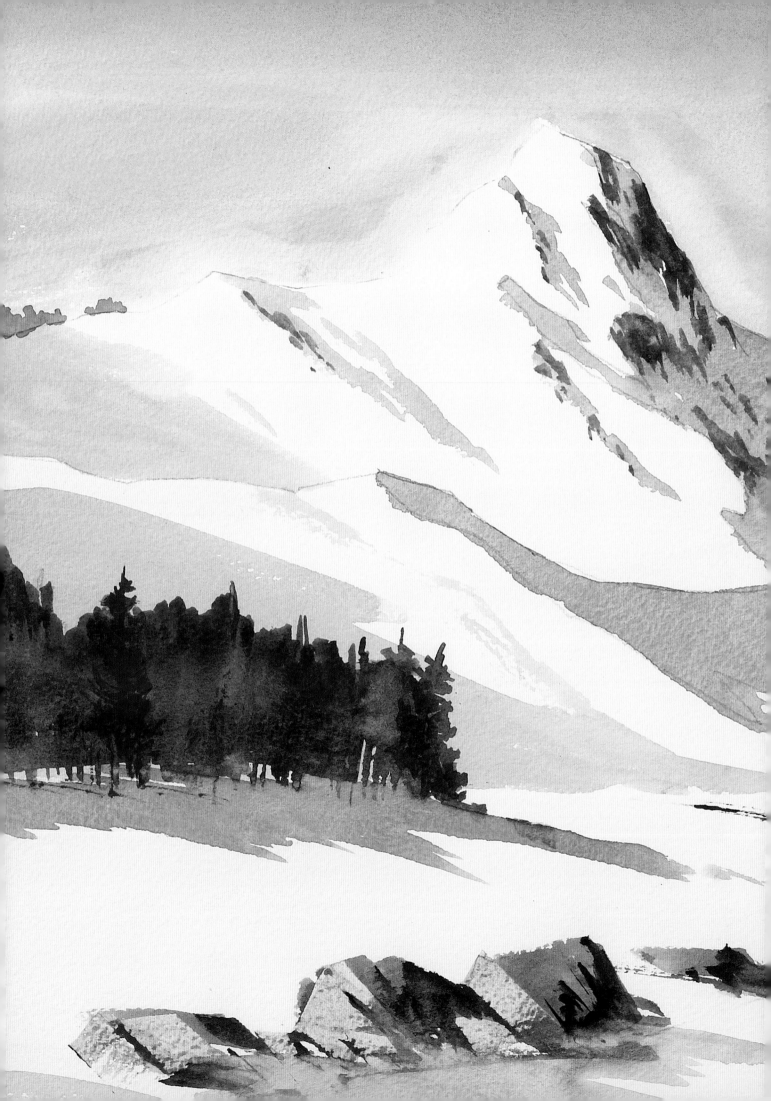

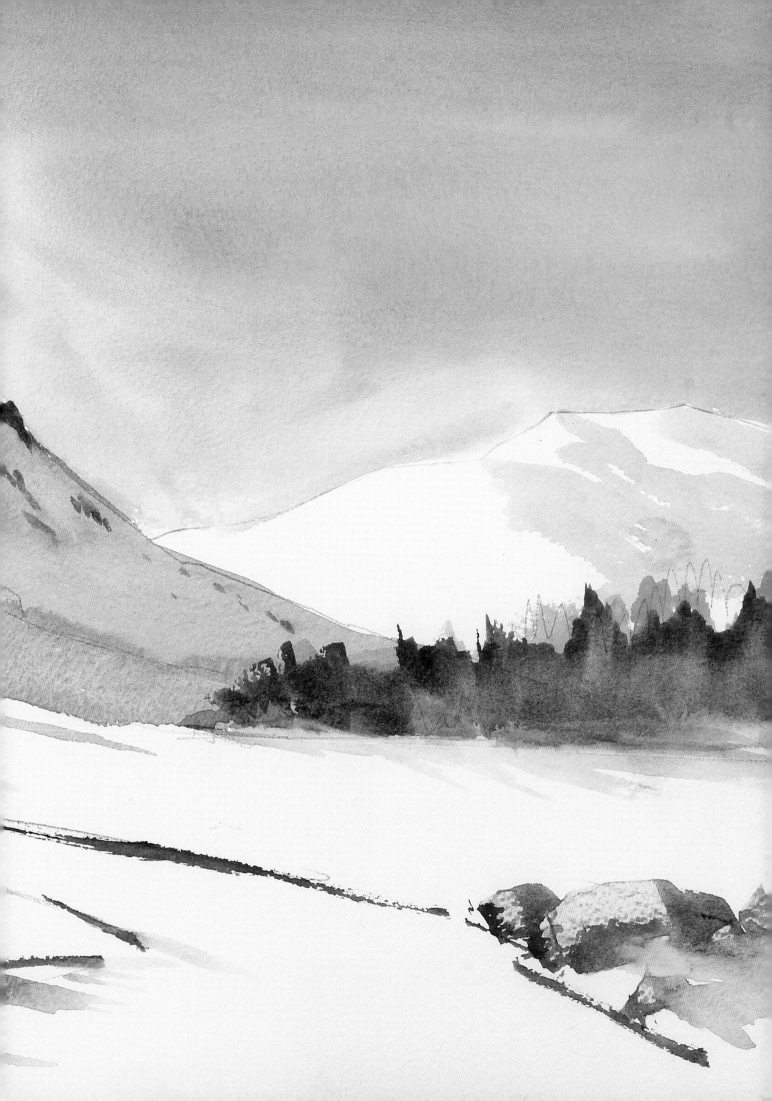

Water's Edge

The light is coming from the left in this painting, so I have scraped out some strata on the cliff face to indicate this. I have painted the cliff face using a number of different colours to enliven the painting and add interest. The lake was added so that I could include some reflections of the landscape, and to create a gentle area as a foil to the hard, textured cliff face.

You will need

180gsm (90lb) NOT watercolour paper
Small piece of sponge
Kitchen paper
Safety razor blade
Kneadable (putty) eraser
Paints: manganese blue hue, cobalt blue, French ultramarine, new gamboge, cadmium lemon, burnt sienna, permanent rose, cadmium orange, cadmium scarlet
Brushes: 25mm (1in) flat brush, 13mm (½in) flat brush with a scraper end, no. 3 rigger

1 Begin in the usual way by dampening the sky area using a damp sponge. Take the water right down to the horizon. Avoid over-wetting the paper.

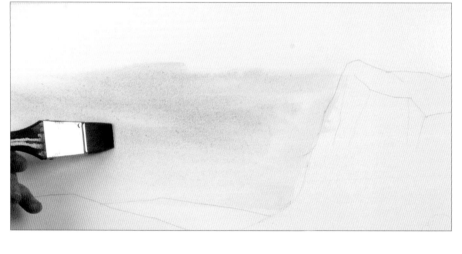

2 Mix up some manganese blue hue and lay on the lower part of the sky using the 25mm (1in) flat brush. Blend out the paint to a paler shade as you move from the top of the sky to the bottom. Move the brush in all directions to avoid streaking.

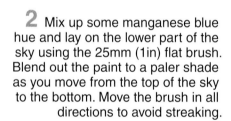

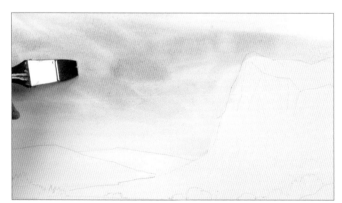

3 For the upper part of the sky use cobalt blue, which is a warmer blue. Blend the two colours together where they meet.

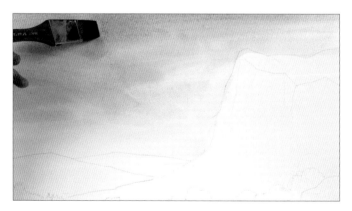

4 At the top of the sky, use French ultramarine mixed with a tiny amount of cadmium scarlet. Blend all the colours together seamlessly to create a gradation from warm to cool blue as you move down the picture.

5 Lift out some wispy clouds by dabbing the wet paint with a screwed-up piece of kitchen paper. Turn the piece of paper continuously to avoid putting back in the paint you have picked up.

6 Make a dry mix of cobalt blue and cadmium scarlet. Re-wet the distant hills, wring out the brush and pick up some colour using a single brushstroke. Place the colour on the top of the furthest hills.

7 Add some new gamboge to the mix and paint the hills in front. Thin the mix down towards the base of the hills. Using a warmer colour as you move towards the foreground will help advance the painting and give it depth.

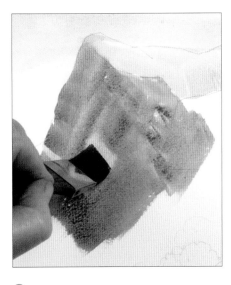

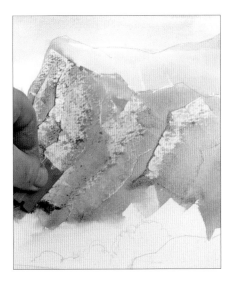

8 Turning to the land at the top of the main mountain on the right, apply a wash of cadmium lemon mixed with a touch of French ultramarine.

9 Continue painting the cliff face down towards the base of the mountain using a variety of colours. Work quickly, so that the colours blend freely on the paper. Begin with a mix of burnt sienna and cobalt blue, then bring in some permanent rose and some new gamboge.

10 Paint the right-hand side of the mountain using the burnt sienna and cobalt blue mix. While the paint is still wet, scrape out the colour using a razor blade to create areas of light (see page 98). These will help define the cliff and give it texture.

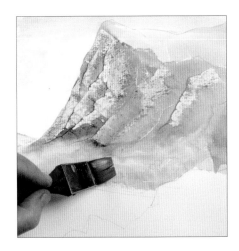

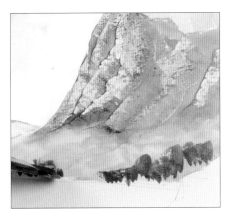

11 Lay a wash of cadmium lemon at the foot of the mountain and blend it into the colours above it.

12 Make a strong mix of new gamboge and French ultramarine and put in the trees at the foot of the mountain. Use the corner of the brush and wiggle it up and down to form the shape of the trees.

103

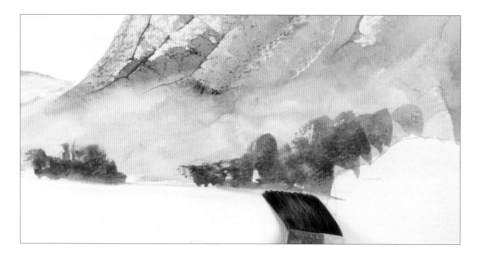

Tip

Place complementary colours, such as red and green, next to each other to enliven and add richness to a painting.

13 While the paint is still wet, put a suggestion of burnt sienna into the green. Straighten the line at the base of the trees with a clean, damp brush.

14 Mix some French ultramarine into the green to cool it down and put in the distant trees on the left. Soften the lower edge of the paint if necessary.

15 Make the purple-grey shadow mix (see page 96) and lay strong shadows diagonally across the cliff face. This will break up the hard edges and put more light into the rocks (the sun is coming from the left).

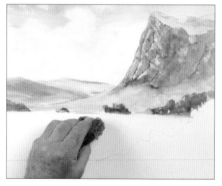

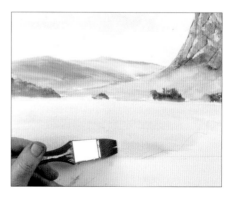

16 Lay some shadows across the land at the top of the mountain too. Soften them with a clean, damp brush.

17 Re-wet the lake area with a damp sponge.

18 Brush in some cobalt blue at the top of the lake, where it reflects the sky.

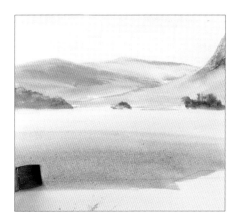

19 Blend in a mix of French ultramarine and cadmium scarlet at the bottom.

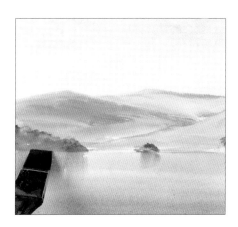

22 Pull some green down from the trees on the left. Use the same mix for the reflections as you used for the trees.

24 Dab some French ultramarine and burnt sienna along the edge of the lake to define it.

Tip

Water reflects the colour of the sky, so use the same colours in each to link them together and create a more realistic picture. In general, always paint reflections using the same colours as the object being reflected.

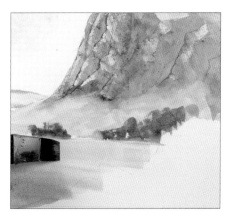

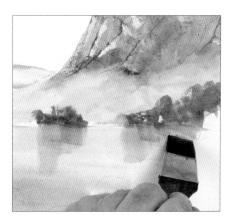

20 While the paint is still wet, put in some new gamboge on the left, below the mountain.

21 Using undiluted French ultramarine mixed with new gamboge, pull down the reflections from the trees. Add a little burnt sienna into the reflections too.

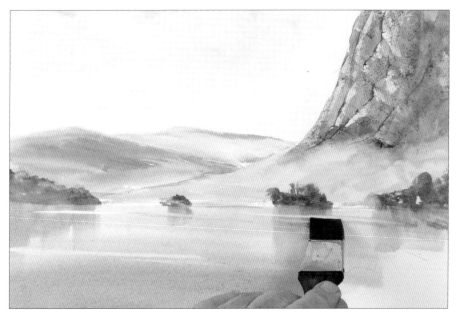

23 Using a clean, damp brush, put in some ripples on the water surface by dragging the flat edge of the brush horizontally through the wet paint.

Tip

When creating ripples, ensure there is less water in the brush than on the paper. The water will then be drawn from the paper to the brush. Move the edge of the brush horizontally across the wet paint to create ripples.

25 Place the rocks on the right-hand side in the foreground by dabbing in first some cadmium orange and then cadmium scarlet.

26 While the paint is still wet, drop in some French ultramarine and some burnt sienna. Allow the colours to mix together on the paper.

27 Scrape out the paint with the razor blade to create light areas and define the shapes of the rocks.

28 Change to the smaller flat brush and darken the area behind the rocks. Use a mix of cadmium scarlet and French ultramarine. Use the same colour to strengthen the reflections in the water.

29 Using the same mix, paint in some grasses around the rocks at the water's edge. Drop in the paint, then use the no. 3 rigger to pull out the grass stems.

30 Shielding the rest of the picture with your hand, splatter in some paint by flicking it off the brush with your finger. This is a good way of adding texture to the rocks.

31 Dab in some flowerheads around the ends of the grasses. Any colour will do for this, though I have used the same mix as I used for the grasses.

32 Mix French ultramarine and burnt sienna, and use the smaller flat brush to strengthen the shadows at the base of the cliff. Soften with a clean, damp brush.

33 Strengthen the shadows at the top of the cliff in the same way.

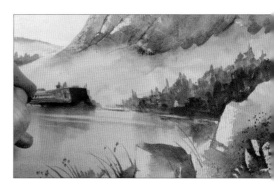

34 Make a mix of French ultramarine and a little new gamboge and put in the suggestion of a forest at the base of the distant hill. This will strengthen the background and lighten the hilltop, pushing it further into the distance.

35 Strengthen the shadow on the right-facing side of the mid-ground hill using the shadow mix (see step 15).

36 Add definition to the forest on the right by painting in a few individual trees using the edge of the brush and a mix of French ultramarine and new gamboge. Space out the trees unevenly so that they do not appear too regimented.

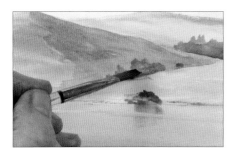

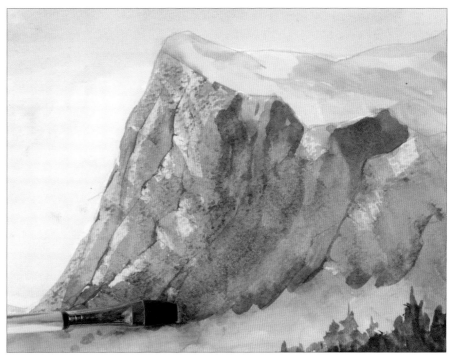

37 Using the same mix as in step 34, put in a few more trees to better define the mid-ground.

38 Knock back the red on the cliff face by laying a grey-blue wash of cobalt blue and some burnt sienna over the top. Use the same mix to add more shadows to the ground at the foot of the mountain and soften them in.

39 Lay the blue-grey wash over the area at the bottom of the cliff to subdue it.

40 When the painting is completely dry, remove any visible lines using a putty eraser.

Overleaf

The finished painting.

107

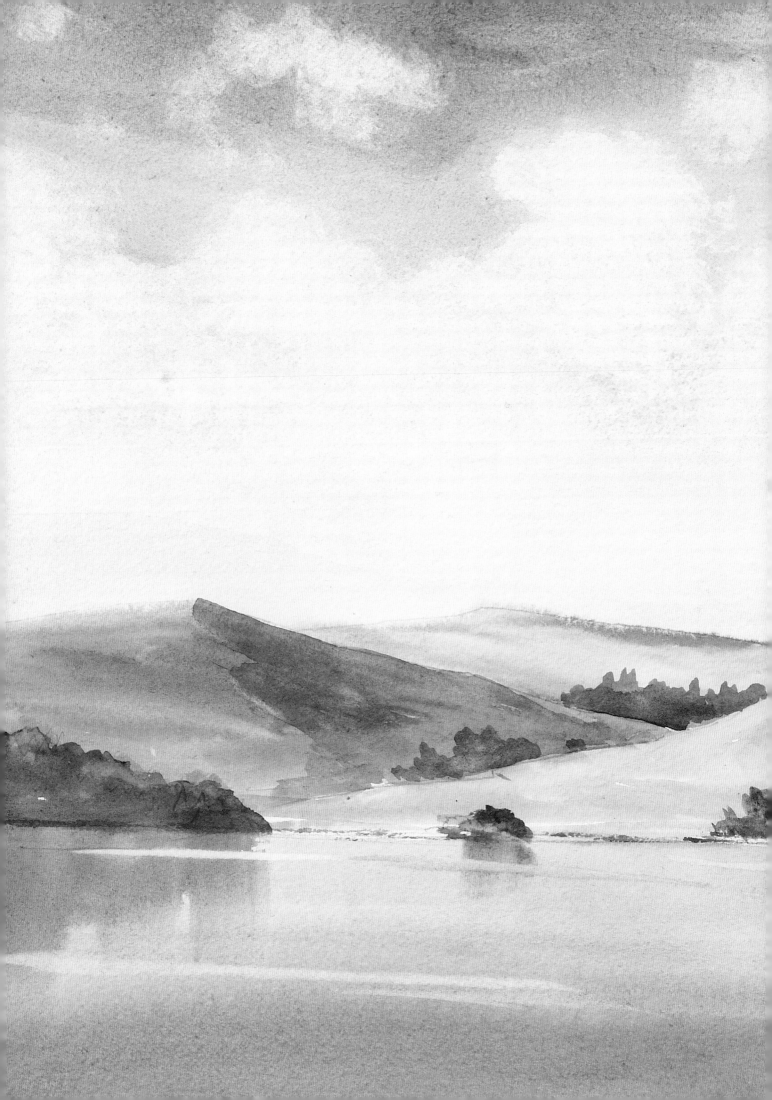

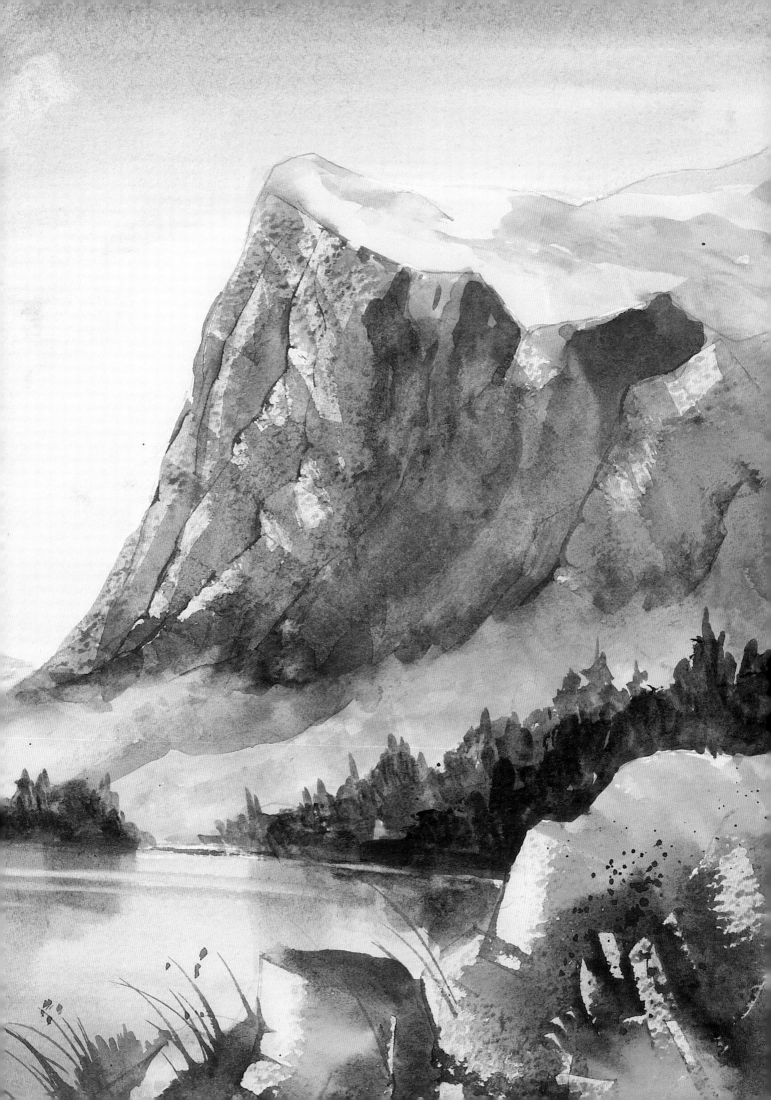

Castle on the Cliffs

The castle dominates this painting, so I have given it a distinctive shape. I have used perspective to emphasise its height above the cliffs, and this effect is further enhanced by the low horizon. Cooler colours in the distant hills and warmer colours in the cliff face and foreground are used to create depth.

You will need

180gsm (90lb) NOT watercolour paper
Kitchen paper
Safety razor blade
Kneadable (putty) eraser
Paints: cobalt blue, French ultramarine, cadmium scarlet, new gamboge, cadmium lemon, permanent rose, burnt sienna, burnt umber and cadmium orange
Brushes: 25mm (1in) flat brush, 13mm (½in) flat brush with a scraper end, no. 3 rigger

1 Begin by dampening the paper all over using the 25mm (1in) flat brush.

2 While the paper is still wet, use the same brush to lay a wash of cobalt blue over the sky. Blend it out so that it is darker at the top than at the bottom.

3 Make a mix of French ultramarine and cadmium scarlet and lay this over the top part of the sky to darken it further.

4 Dab out a suggestion of clouds using a crumpled piece of dry kitchen paper. Turn the piece of paper continuously to avoid putting back in the paint you have picked up.

5 Sharpen the edge of the cliff face by scraping away the paint using a razor blade.

6 While the paint is still wet, make a mix of French ultramarine and cadmium scarlet. Wring out the brush and pick up the paint with a single stroke (this ensures there is just the right amount of water on the brush). Put in the distant mountain on the left.

7 When the sky is dry, make a very pale mix of new gamboge and a touch of cadmium scarlet and paint in the castle using the smaller flat brush. Go around the outline carefully.

8 Change back to the 25mm (1in) flat brush, add some cadmium lemon to the mix and paint in the top of the cliffs.

9 Continue painting the cliffs, using first permanent rose, followed by cobalt blue and then new gamboge. Work quickly, blending the colours on the paper while the paint is still wet.

Tip

Always clean your palette with a damp kitchen sponge and wash out your brush between colours.

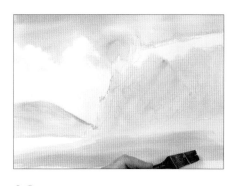

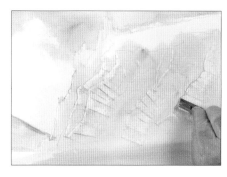

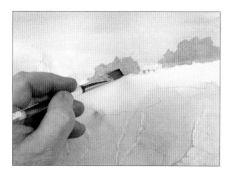

10 Paint in the ground at the bottom of the cliff using first cadmium lemon, followed by a layer of new gamboge, then finish with burnt sienna along the base of the picture. As before, work quickly and blend the colours on the paper. Use long, sweeping brushstrokes.

11 Working your way from left to right across the painting, and while the paint is still wet, scrape out the shapes of the rocks on the cliff face using the razor blade. Scraping out the colour in this way creates areas of light with hard edges (see page 98), giving form and definition to the cliff face.

12 Mix together some cobalt blue and new gamboge and 'dab on' the trees at the top of the cliff using the smaller flat brush.

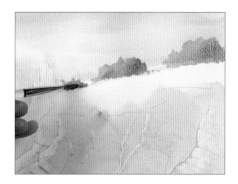

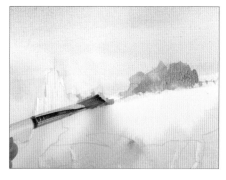

13 Make another mix with more blue and less yellow and put in the shadows on the right-hand sides of the trees.

14 Clean the brush and use the corner of it to soften in the edges of the trees.

15 Using the standard shadow mix of cobalt blue, permanent rose and cadmium scarlet and the larger flat brush, paint on the shadows on the right-hand side of the distant mountain.

16 Change back to the smaller flat brush and put in the shadows on the sides of the castle facing away from the light. These are the form shadows. Use the flat edge of the brush.

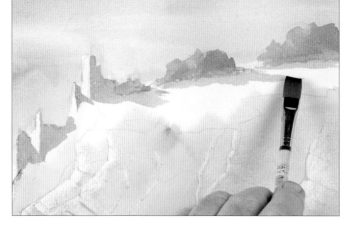

17 Use the same technique to put in the cast shadows sweeping away from the castle towards the right of the picture. Soften the edges of the shadows here and there using a clean, damp brush.

18 Put in the shadows on the cliff face to accentuate the light and help define the shapes of the rocks. Work your way across from left to right, linking the shadows in with the cast shadows at the top of the cliff on the left and with each other. Soften in the edges as you work.

Tip

When using a razor blade to scrape out highlights, make sure the paint is still wet and place the razor blade with the edge flat on the surface. Tilt the blade in the direction you wish to scrape and push the pigment firmly in that direction. Be careful not to cut yourself.

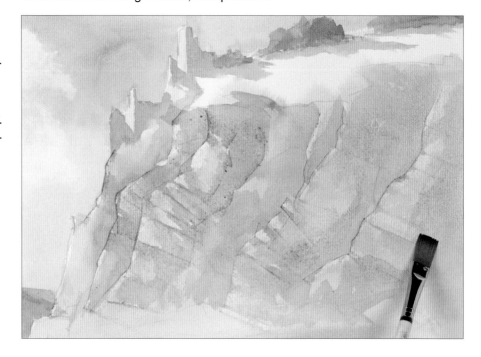

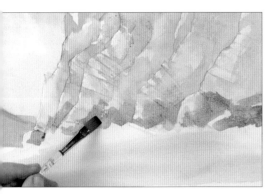

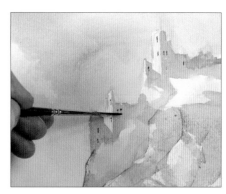

19 Mix together some cobalt blue and burnt sienna and put in the dark shadows on the rocks at the bottom of the cliff, leaving the light areas bare.

20 Use the razor blade to scrape out the smaller rocks at the front (see tip above). Soften the lower edge of the rocks using a clean, damp brush.

21 Make sure the castle is dry then put in the windows using the rigger and a dark mix of French ultramarine and burnt umber.

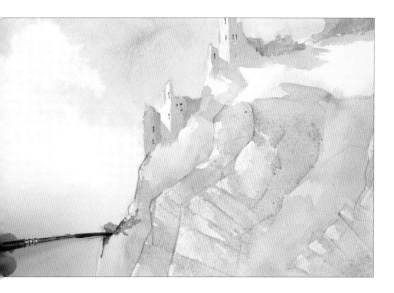

22 Using a mix of French ultramarine and cadmium scarlet, put more light into the castle by adding small patches of dark shadows behind it. Also deepen the rocky outcrop below it. Soften the edges.

Tip

Enhance the sunlit areas of your painting by deepening the shadows. Soften them in, but retain a hard edge where the lightest and darkest parts of the painting meet.

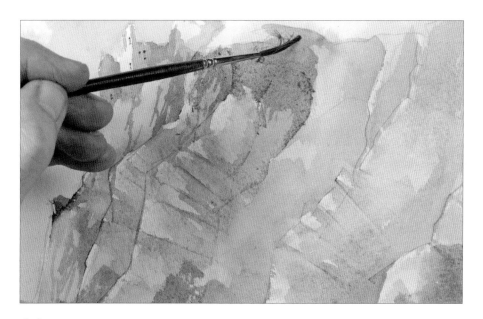

24 To avoid introducing too much detail, change to the large flat brush for the flatter areas on the right.

23 With the same mix, continue to deepen the darkest shadows on the cliff face. Use the rigger to work in more detail.

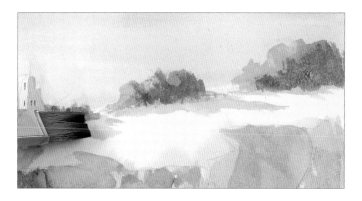

25 Using a mix of French ultramarine, new gamboge and cadmium scarlet, darken the right-hand sides of the trees. Apply the paint using the side of the brush for a 'sparkly' finish (see page 90).

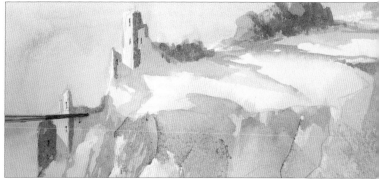

26 With the same mix, change to the rigger and extend the cast shadows on the top of the cliff. Also strengthen the shadows on the castle where they lie adjacent to the lightest areas and to the sky.

27 Use the large flat brush to dampen the area of water.

28 Put in the blue using a mix of French ultramarine and a little cadmium scarlet. Wring out the brush and define the water's edge by drawing along it with the flat edge of the brush.

29 Put in the large foreground rocks using a wash of cadmium orange followed by French ultramarine.

30 Scrape out the rocks, as you did in step 20.

31 Make a mix of new gamboge and cobalt blue and, holding the rigger right at the end, paint in some grasses using swift, curving strokes of the brush.

32 For the lighter-coloured grasses, use the same movement, but scrape them out with the scraper end of the 13mm (½in) flat brush.

33 Using the larger flat brush, put more shadows on the right-hand side of the picture to draw the eye towards the castle.

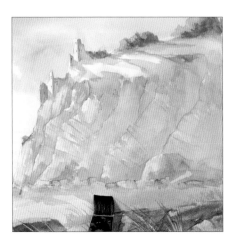

34 Also bring in more shadow at the foot of the cliff to force the eye into the centre of the painting.

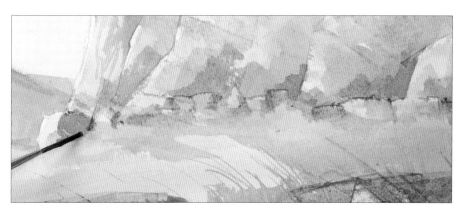

35 Darken the lower part of the water using cobalt blue and cadmium scarlet to enhance the suggestion of sunlight at the edge of the lake.

Tip

Remember to soften in the colour as you paint to avoid hard edges and give a more natural finish to your painting.

36 Change to the rigger, and put more sunlight on to the rocks at the foot of the cliff by deepening the shadows on their right-hand sides.

37 Also darken the corner of the lake adjacent to the cliff to accentuate the sunlight falling on to the rock furthest to the left.

Tip

Complete your painting by removing any visible pencil lines when it is completely dry.

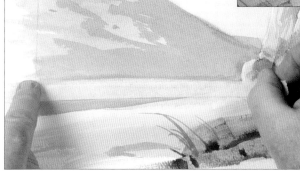

38 If necessary, straighten the edge of the lake by laying the top edge of a piece of masking tape along it and pressing it down firmly on to the paper. (Make sure the paint is completely dry before you do this.)

39 Using the same mix as you used in step 28, apply the paint by brushing from the top edge of the tape on to the paper. Soften the edge with clean water.

40 When the paint is dry, pull the masking tape away from the painting.

Overleaf

The finished painting.

115

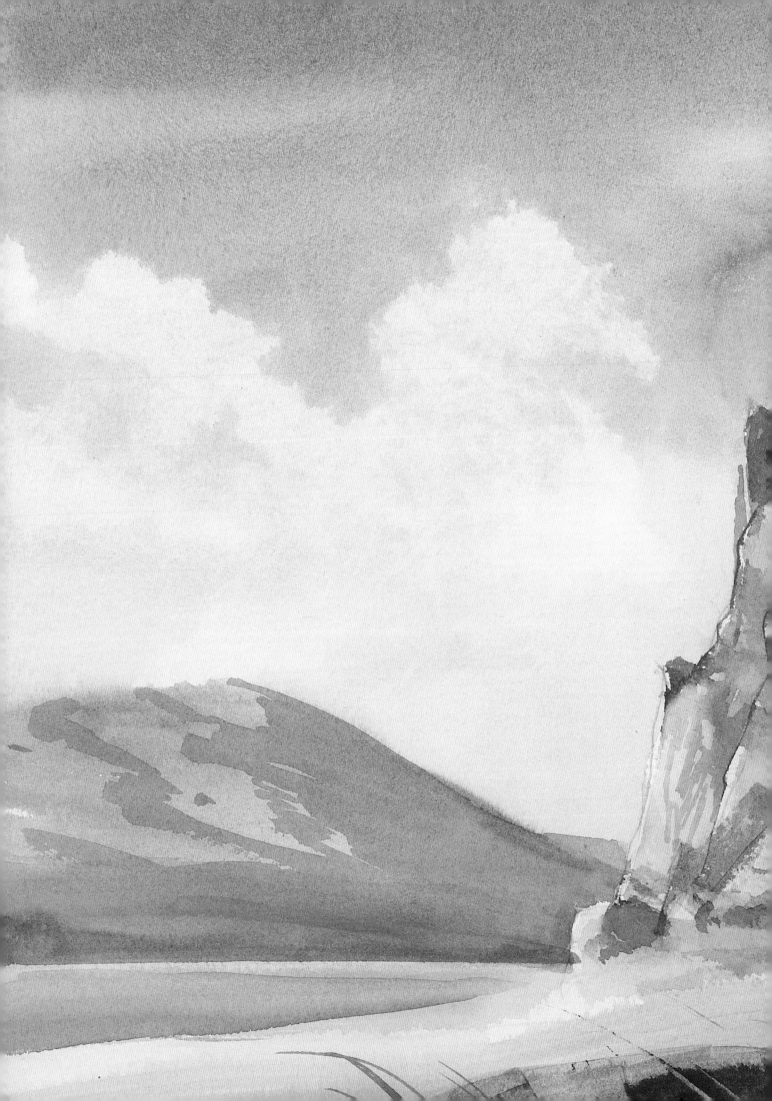

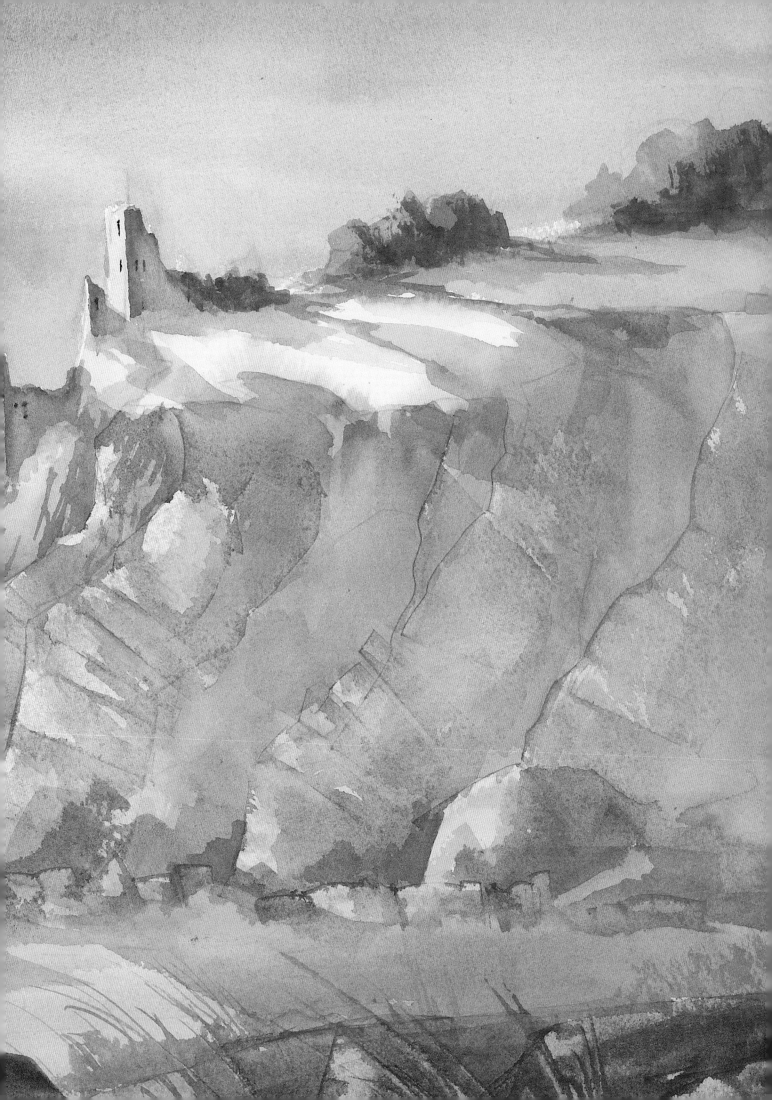

Mountain Stream

I wanted to emphasise the gentleness of the rolling hills in the distance in this painting, so I placed a waterfall in the foreground to act as a foil. For variety I added a ploughed field. The foreground water and the sky are soft and calm, which helps to force the eye to the central area of the painting, which is where I want the viewer to look.

You will need

180gsm (90lb) NOT watercolour paper
Small piece of sponge
Kitchen paper
Safety razor blade
Kneadable (putty) eraser
Brushes: 25mm (1in) flat brush; 13mm (½in) flat brush with a scraper end; no. 3 rigger
Paints: Winsor blue (green shade), cadmium scarlet, cadmium lemon, new gamboge, burnt sienna, cobalt blue, cadmium orange, permanent rose, burnt umber, French ultramarine, titanium white

1 Begin by dampening the sky using a damp sponge. Avoid over-wetting the paper.

2 Before it dries, make a thin mix of Winsor blue (green shade) and a tiny amount of cadmium scarlet and paint in the sky, taking the colour down over the tops of the mountains. Use the 25mm (1in) flat brush.

3 Dab out a suggestion of clouds using a crumpled piece of dry kitchen paper.

4 Add a little cadmium scarlet to the mix and put in the tops of the distant mountains using the smaller flat brush. Fade the colour out towards the bottom.

5 Use a little cadmium lemon to put in the hill in the mid-ground. Moving forwards towards the foreground, put in the next hill using new gamboge, and the one in front of that using burnt sienna.

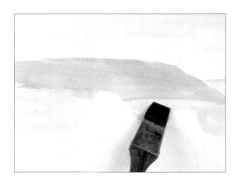

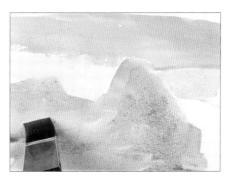

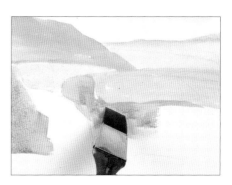

6 For the hill on the left, use more autumnal colours – new gamboge, cadmium scarlet and a little cobalt blue. Apply the paint with the larger flat brush. Paint the area in front of the hill using a mix of Winsor blue (green shade) and a little cadmium lemon.

7 Begin to put in the rocks in the foreground. Use new gamboge, a little cadmium orange and some cadmium scarlet, a touch of cobalt blue and some permanent rose. Lay the colours in separately and allow them to mix on the paper.

8 For the rocks in the middle of the picture use cadmium orange, new gamboge and some cadmium scarlet.

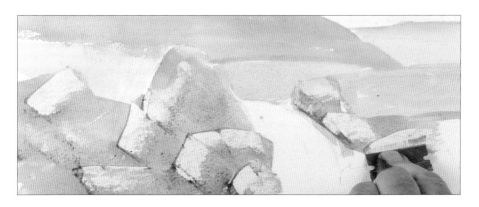

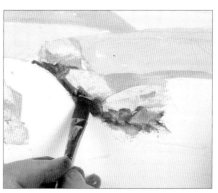

9 Use a razor blade to scrape away the paint where the sunlight catches the rocks. This adds depth and texture. (The light is coming from the left.)

10 Using the small flat brush, put in some dark foliage and strengthen the edge of the waterfall. Use Winsor blue (green shade) and burnt umber.

Tip

When using a razor blade to scrape out highlights, make sure the paint is still wet and place the razor blade with the edge flat on the surface. Tilt the blade in the direction you wish to scrape and firmly push the pigment in that direction.

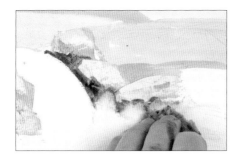

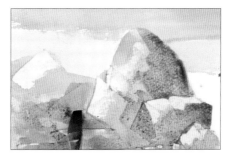

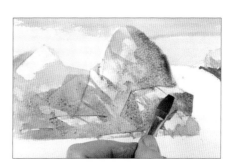

11 Work into the paint firmly with a damp sponge, pushing the pigment to one side. This creates soft patches of white, which will eventually become areas of spray rising from the waterfall.

12 Make up a small quantity of shadow mix (see page 96) and put in the shadows on the left-hand rocks.

13 Put in the diagonal shadows cast by the trees. Soften the base of the rocks with a damp sponge if necessary.

119

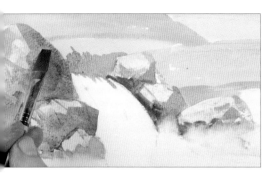

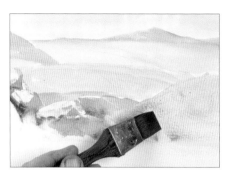

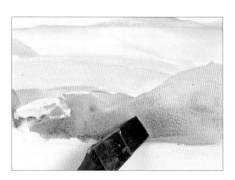

14 Add shadows to the rocks on the right, and use the same mix to put in the suggestion of distant foliage at the top of the waterfall. Introduce more cadmium orange into the foreground rocks on the left.

15 Paint the area of foreground on the right of the picture using a mixture of yellows, blues, reds and oranges. Apply them singly and allow them to blend on the paper.

16 Darken the lower area using burnt sienna and French ultramarine.

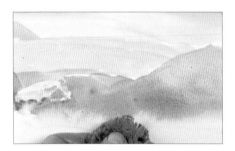

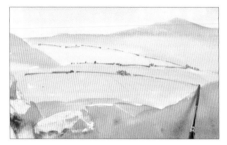

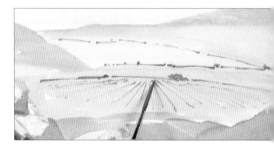

17 Push a damp sponge up into the lower edge of the paint to suggest foam at the base of the waterfall.

18 Using the no. 3 rigger, put in the distant hedgerows as thin, irregular, broken lines with occasional dots of paint for trees and shrubs. For those in the distance use a mix of new gamboge and cobalt blue; for those further forwards add a little more red.

19 With the more red version of the mix, draw in the thin, radiating lines denoting the furrows of the ploughed field.

20 Start to place the main trees on the left. Use the larger flat brush and the same green mix as in the previous step. Apply the paint with the flat edge of the brush and using horizontal strokes, pulling the paint from one side of the trunk to the other.

21 Returning to the rigger, put in three trunks, all at slightly different angles, then add a little more blue to the mix and put in the main branches at the tops of the trees. Paint each branch with a single, sweeping stroke from the trunk to its tip.

22 Use the shadow mix (see step 12) to lay in the shadows down the right-hand sides of the tree trunks (the light is coming from the left).

23 For the foliage, make a mix of cobalt blue, cadmium lemon and a touch of cadmium orange. Dab the paint on firmly using the corner of the 25mm (1in) flat brush – this will give your painting a more 'sparkly' finish (see page 96).

24 Add a little red to the mix for the darker foliage at the bottom and on the right.

25 Use the darker green to put in some shrubs at the base of the trees and on the right-hand side of the waterfall.

26 With the standard shadow mix (see page 96), use the flat edge of the brush to place the shadows on the right-facing side of the mid-ground mountains and across the fields in the background.

27 Use the corner of the brush to paint on the shadows on the waterfall, in the same direction as the flow of the water.

28 Strengthen the shadows on the rocks on the left and on the area of ground on the right.

29 Make a dark mix of burnt sienna and French ultramarine and put in the darks at the base of the ground to the right of the waterfall. Soften the edges with a clean, damp brush.

30 Use a damp sponge to soften the bottom edge here and there, where it meets the edge of the water.

31 Put in the shrubs and bushes on the right using the light green mix used for the foliage in step 23 (cobalt blue, cadmium lemon and a touch of cadmium orange).

32 Strengthen the colour with the darker green, then paint in some branches using the burnt sienna and French ultramarine mix and the no. 3 rigger.

121

33 Scrape out the rocks below the shrubs using the razor blade, as you did in step 9.

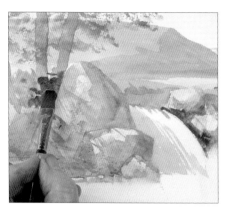

34 Using a very dark green mix of cadmium lemon, French ultramarine and cadmium scarlet, darken the foliage at the base of the large trees on the left. This will make the light areas look lighter. Use the smaller flat brush.

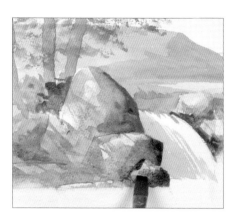

35 Make a cooler version of the mix by adding some cobalt blue and place a strong shadow down the right-hand side of the main rocks. Soften it in with a clean, damp brush.

36 Using a slightly weaker version of the same mix, place more shadows on the remainder of the rocks. Soften them in as before.

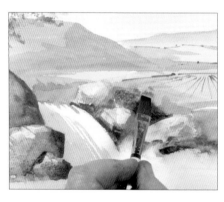

37 Apply shadows to the right-hand rocks in the same way.

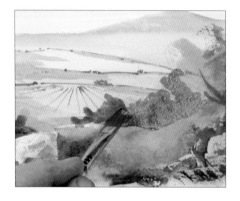

38 Deepen the colour of the shrubs and bushes on the right-hand side of the picture using the same dark green mix as the one you used in step 34.

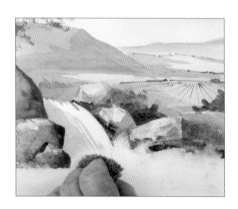

39 Soften the edges of the waterfall using a damp sponge, if these have started to dry.

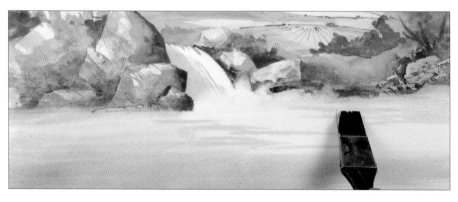

40 Dampen the area of water with a clean, damp sponge, then paint it using a pale mix of cobalt blue (the same colour as that used for the sky). Apply the paint using horizontal strokes of the larger flat brush. Create ripples by moving the edge of the brush horizontally across the wet paint. Ensure there is less water in the brush than on the paper – the water will then be drawn from the paper to the brush. Leave the area in front of the waterfall free of colour.

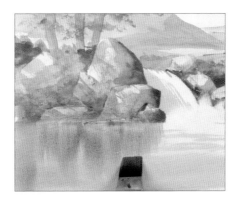

41 Using the same variety of colours you used for the rocks, drag the reflections from the base of the rocks into the water. Try to keep the tonal values the same.

42 Do the same on the other side of the picture.

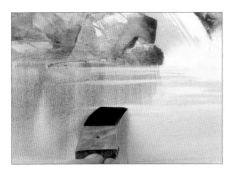

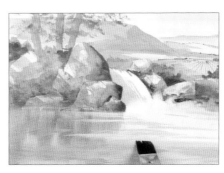

43 Clean the brush thoroughly and extend the ripples into the reflections using the technique described in step 40.

44 Pull some of the darks into the middle part of the water.

45 Add more shadows to the rocks where necessary to make them stand out against the background. Use the no. 3 rigger.

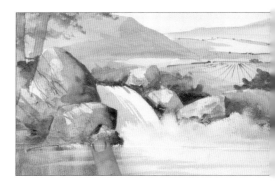

46 Using a very dark brown mix of French ultramarine and cadmium scarlet paint in the cracks on the left-hand rocks.

47 Put more of this mix behind the waterfall at the top to make the waterfall appear brighter. Soften it in with a clean, damp brush.

48 To create foam, use your finger to roll some undiluted titanium white into the bottom of the waterfall where it hits the water and the rocks. Do the same at the base of the rocks on the left.

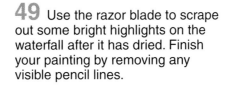

49 Use the razor blade to scrape out some bright highlights on the waterfall after it has dried. Finish your painting by removing any visible pencil lines.

Overleaf

The finished painting.

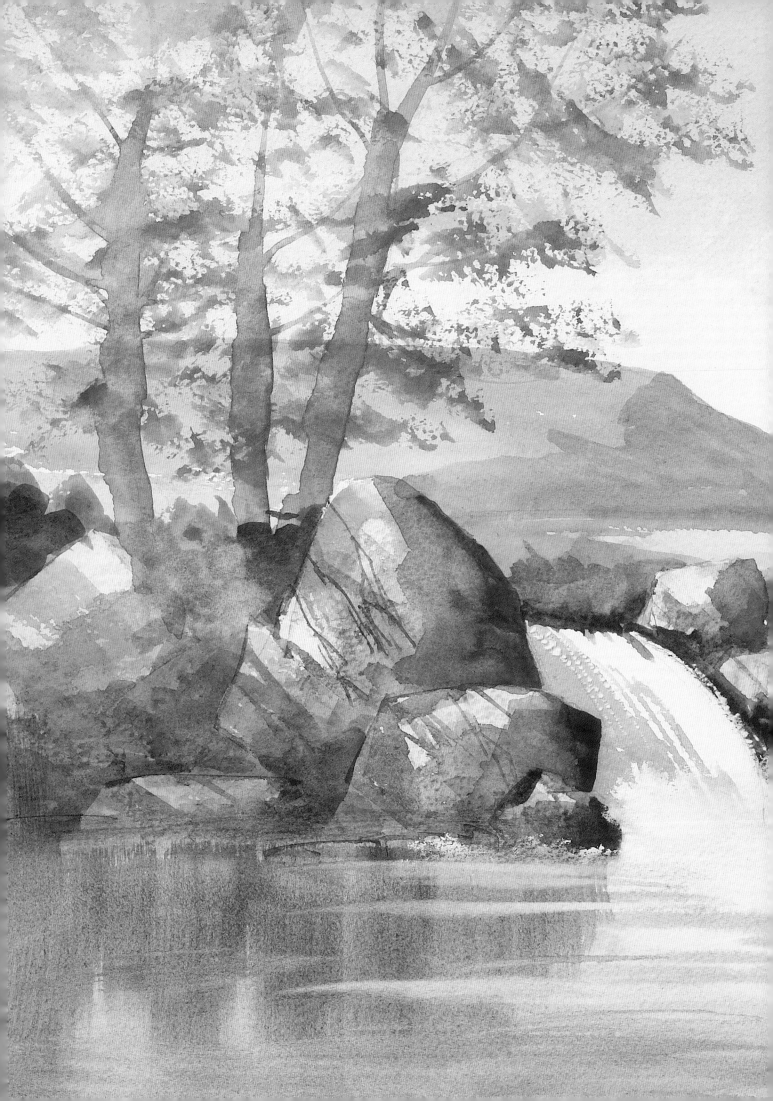

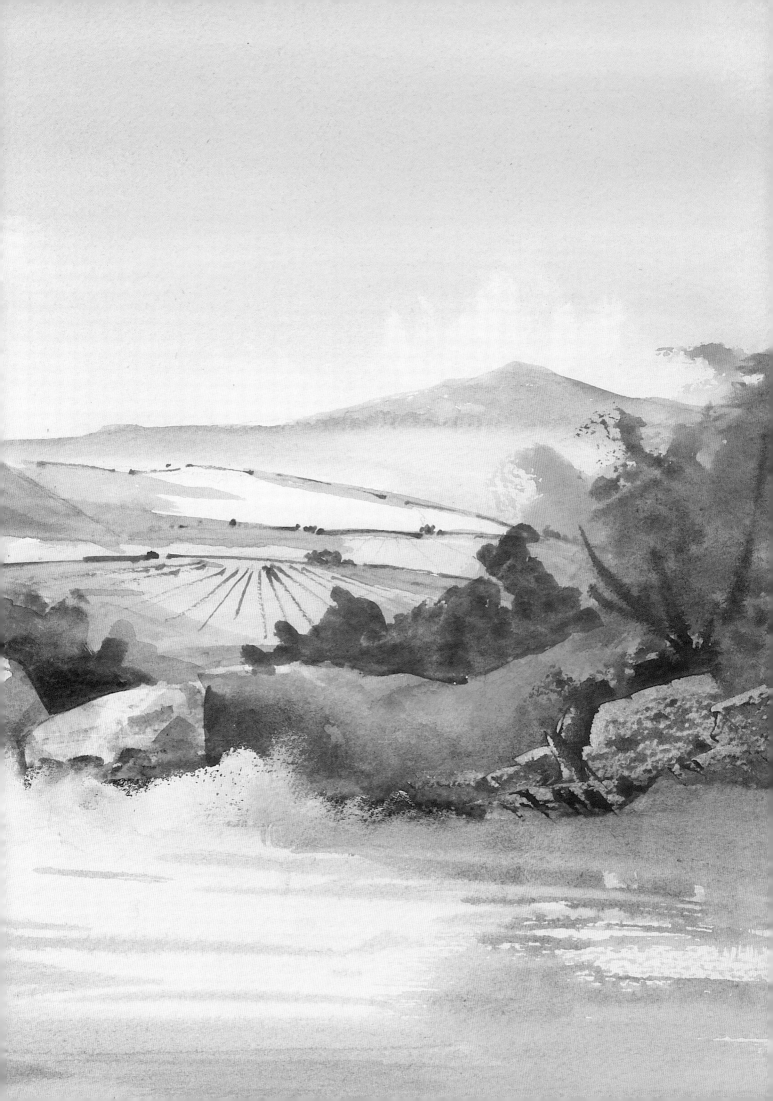

A Burst of Sun

76 x 56cm (30 x 22in)

Sometimes bursts of sunlight appear through patches of cloud, lighting up parts of the countryside. I have tried to capture this effect in this painting. The rock textures were created by scraping out the paint using a safety razor blade.

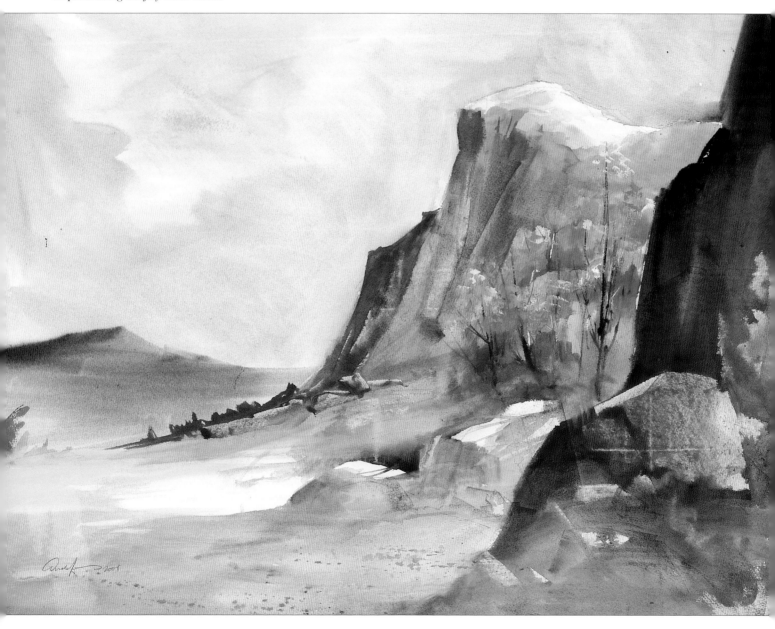

Sunlit cliff

56 x 76cm (22 x 30in)

The cliff is painted in warm colours in this scene, in contrast to the blue, distant hills, which are partially covered in cloud. The water's edge is bathed in sunlight.

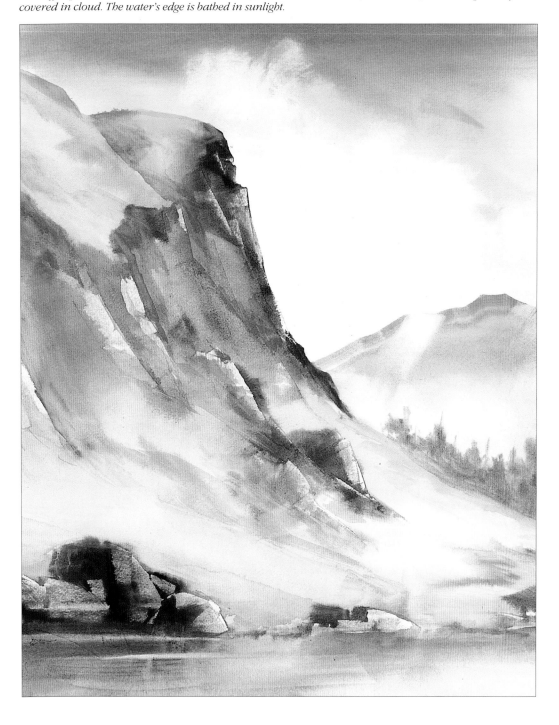

Index

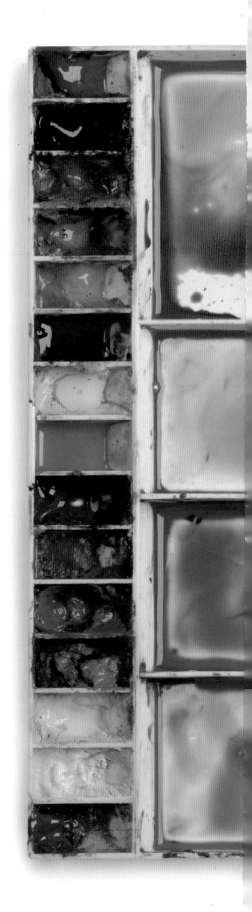